Portrait of

ARIZONA

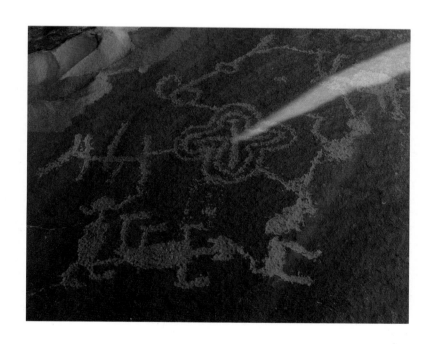

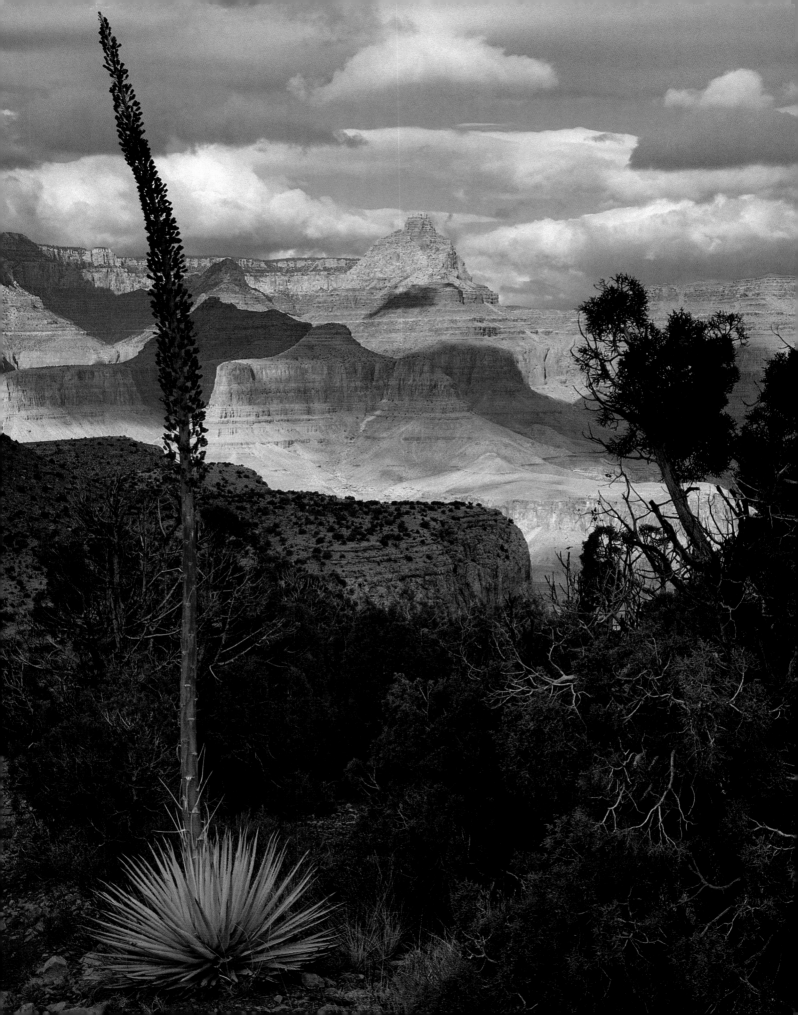

Portrait of
ARIZONA

PHOTOGRAPHY BY FRED HIRSCHMANN

ESSAYS BY SCOTT THYBONY

GRAPHIC ARTS CENTER PUBLISHING®

International Standard Book Number 1-55868-239-2
Library of Congress Number 75-75451
Photographs © MCMXC by Fred Hirschmann
Essays © MCMXC by Graphic Arts Center Publishing®
P.O. Box 10306 • Portland, Oregon 97210 • 503/226-2402
President • Charles M. Hopkins
Editor-in-Chief • Douglas A. Pfeiffer
Managing Editor • Jean Andrews
Production Manager • Richard L. Owsiany
Cartography • Manoa Mapworks, Inc.
Book Manufacturing • Lincoln & Allen Co.
Printed in the United States of America

Half Title Page: Forty-five days prior to winter solstice, a shaft of sunset light pierces the center of a cross. The petroglyph, in Petrified Forest National Park's backcountry, is believed by archeo-astronomers to be an Anasazi solar calendar. *Frontispiece:* After producing just one flowering stalk in its lifetime, a century plant turns yellow and dies on Horseshoe Mesa in the Grand Canyon.

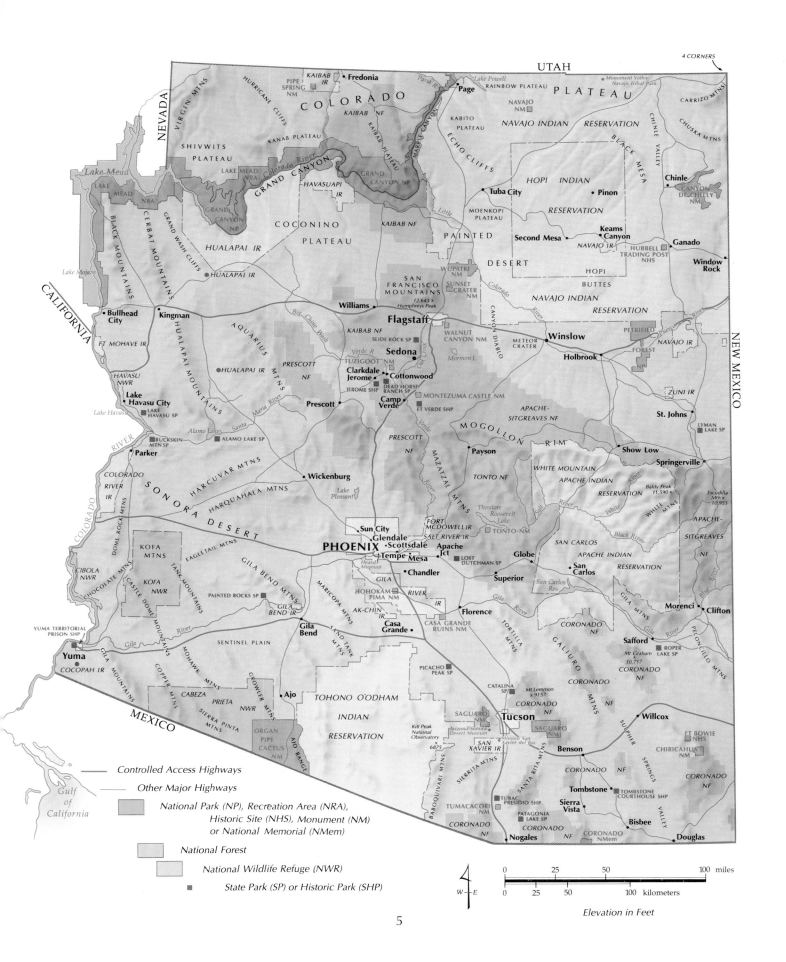

Map of Arizona

UTAH

NEVADA

CALIFORNIA

NEW MEXICO

MEXICO

4 CORNERS

COLORADO PLATEAU

Lake Powell
RAINBOW PLATEAU
Monument Valley
Navajo Tribal Park

CARRIZO MTNS

Paria R.

• Fredonia
KAIBAB IR
PIPE SPRING NM

• Page

NAVAJO NM

HURRICANE CLIFFS

KANAB PLATEAU

SHIVWITS PLATEAU

VIRGIN MTNS

Lake Mead
LAKE MEAD NRA

KAIBAB NF

KAIBAB PLATEAU

ECHO CLIFFS

KABITO PLATEAU

CHINLE VALLEY

CHUSKA MTNS

• Chinle

CANYON DE CHELLY NM

NAVAJO INDIAN RESERVATION

BLACK MESA

HOPI INDIAN RESERVATION

• Tuba City

• Pinon

MOENKOPI PLATEAU

Little

Second Mesa •

Keams Canyon •

• Ganado

NAVAJO IR

HUBBELL TRADING POST NHS

GRAND CANYON
LAKE MEAD NRA
Colorado River
GRAND CANYON NP
HAVASUAPI IR
GRAND CANYON NP

HUALAPAI IR

COCONINO PLATEAU

PAINTED DESERT

Window Rock

HOPI BUTTES

NAVAJO INDIAN RESERVATION

Colorado River

Canyon Diablo

WUPATKI NM
SUNSET CRATER NM

• Williams

SAN FRANCISCO MOUNTAINS
12,643 × Humphreys Peak

Flagstaff

METEOR CRATER

• Winslow

PETRIFIED FOREST

NAVAJO IR

Black Mountains
CERBAT MOUNTAINS
GRAND WASH CLIFFS

• Bullhead City
• Kingman

KAIBAB NF

SLIDE ROCK SP

WALNUT CANYON NM

• Holbrook

ZUNI IR

AQUARIUS MTNS

Big Chino Wash

Verde R.
Sedona •
TUZIGOOT NM
Clarkdale
Jerome • Cottonwood
DEAD HORSE RANCH SP
JEROME SHP

Mormon L.

St. Johns

LYMAN LAKE SP

FT MOHAVE IR

HUALAPAI MOUNTAINS

PRESCOTT NF

• Hualapai IR

HAVASU NWR

Lake Havasu City

LAKE HAVASU SP

Lake Havasu

Santa Maria River

PRESCOTT NF

MONTEZUMA CASTLE NM
Camp Verde
FT VERDE SHP

APACHE-SITGREAVES NF

MOGOLLON RIM

BUCKSKIN MTN SP

Alamo Lake
ALAMO LAKE SP

• Parker

HARCUVAR MTNS

• Prescott

Verde River

• Payson

• Show Low
Springerville

COLORADO RIVER IR

HARQUAHALA MTNS

• Wickenburg

MAZATZAL MTNS

TONTO NF

WHITE MOUNTAIN APACHE INDIAN RESERVATION

Baldy Peak 11,590 ×

Escudilla Mtn × 10,955

DOME ROCK MTNS

Lake Pleasant

Theodore Roosevelt Lake

Salt River

White River

Black River

SONORA DESERT

KOFA MTNS

EAGLETAIL MTNS

Sun City
Glendale
• Scottsdale
PHOENIX
Tempe Mesa

FORT McDOWELL IR
SALT RIVER IR

Apache Jct

LOST DUTCHMAN SP

• Globe

SAN CARLOS

APACHE INDIAN RESERVATION

APACHE-SITGREAVES NF

KOFA NWR

TANK MOUNTAINS

GILA BEND MTNS

Gila

• Chandler

Heard Museum

Gila River

• Superior

San Carlos Res

• San Carlos

CIBOLA NWR

CHOCOLATE MTNS

CASTLE DOME MOUNTAINS

PAINTED ROCKS SP

GILA BEND IR

HOHOKAM PIMA NM

AK-CHIN IR

RIVER

Gila River

• Florence

CORONADO NF

GILA MTNS

Morenci •
• Clifton

YUMA TERRITORIAL PRISON SHP

River

SAND TANK MTNS

• Gila Bend

CASA GRANDE RUINS NM
Casa Grande •

Gila River

Safford •
ROPER LAKE SP

GALIURO MTNS

PELONCILLO MTNS

• Yuma

COCOPAH IR

Gila

SENTINEL PLAIN

TORTILLA MTNS

Mt Graham 10,717 ×

CORONADO NF

COPPER MTNS

MOHAWK MTNS

PICACHO PEAK SP

• Ajo

GROWLER MTNS

TOHONO O'ODHAM INDIAN RESERVATION

CATALINA SP

Mt Lemmon × 9157

CORONADO NF

• Willcox

CABEZA PRIETA NWR

SIERRA PINTA MTNS

SAGUARO NM
Kitt Peak National Observatory
6875 ×

Tucson

CORONADO NF

FT BOWIE NHS

ORGAN PIPE CACTUS NM

AJO RANGE

Arizona-Sonora Desert Museum
SAGUARO NM

SAN XAVIER IR

Mission San Xavier del Bac

SANTA RITA MTNS

• Benson

SULPHUR SPRINGS VALLEY

CHIRICAHUA NM

BABOQUIVARI MTNS

TUMACACORI NM

TUBAC PRESIDIO SHP

• Tombstone
TOMBSTONE COURTHOUSE SHP

Sierra Vista

CORONADO NF

SIERITA MTNS

• Bisbee

PATAGONIA LAKE SP

Nogales •

CORONADO NF

CORONADO NMem

• Douglas

Gulf of California

Controlled Access Highways

Other Major Highways

National Park (NP), Recreation Area (NRA), Historic Site (NHS), Monument (NM) or National Memorial (NMem)

National Forest

National Wildlife Refuge (NWR)

State Park (SP) or Historic Park (SHP)

N
W — E
S

0 25 50 100 miles

0 25 50 100 kilometers

Elevation in Feet

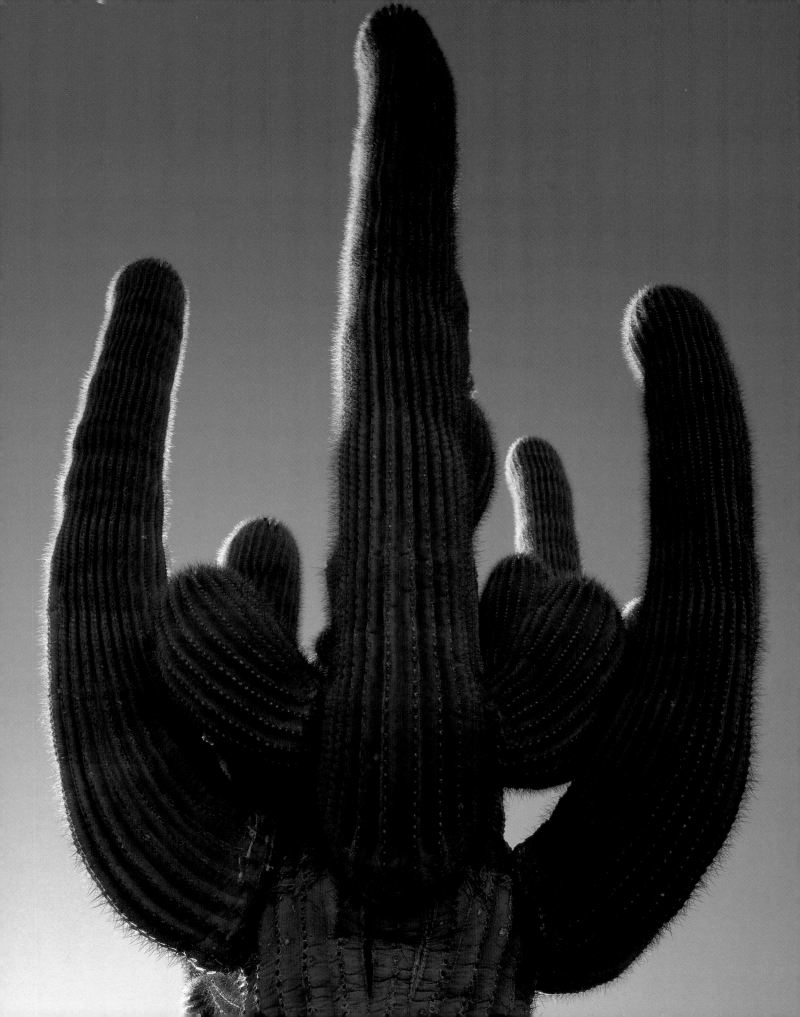

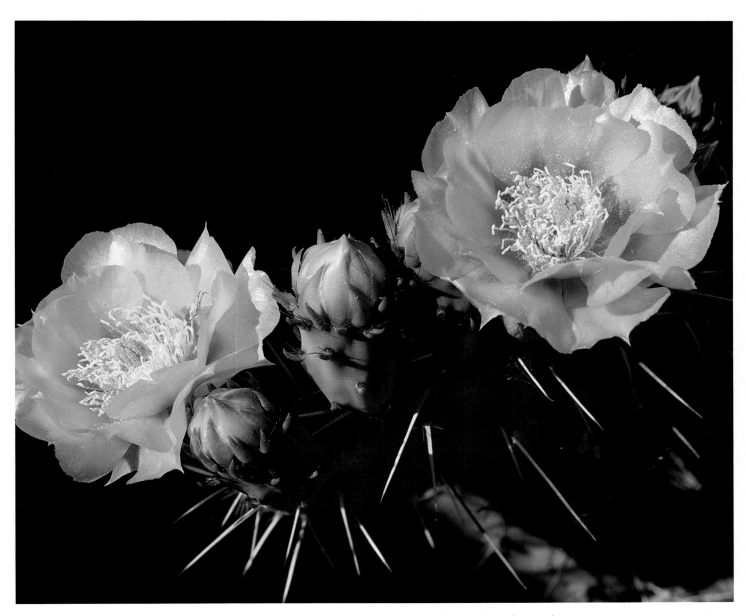

◄ A mature saguaro spreads its arms to desert sky above the Antelope Hills of the Cabeza Prieta National Wildlife Refuge. In addition to protecting stately saguaros, Cabeza Prieta provides a critical habitat for desert bighorn sheep and the endangered Sonoran pronghorn antelope. ▲ Yellow blossoms of spring grace a prickly pear in the Tucson Mountain Unit of Saguaro National Park.

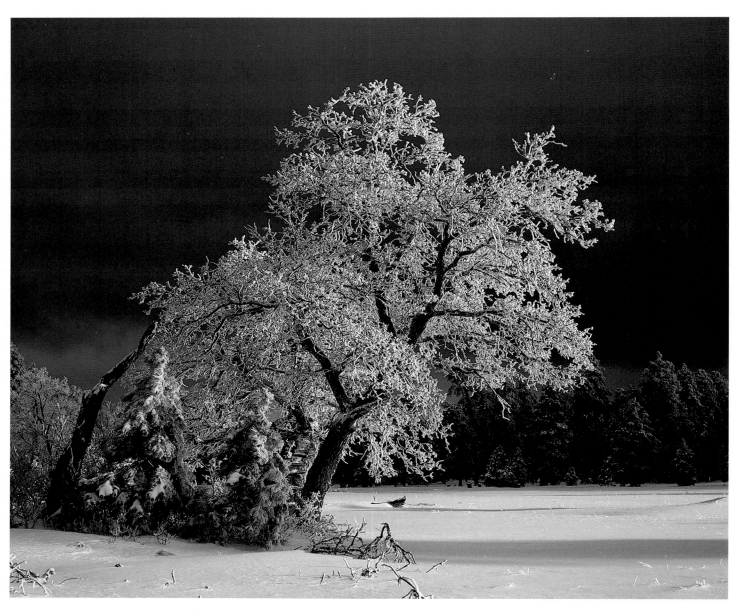

▲ Rime and fresh snow cling to oak branches as a storm breaks over the Mogollon Rim. At an elevation of nearly eight thousand feet, in winter the rim is sometimes enveloped by ice fog.
▶ Incised in the slickrock desert of northern Arizona, a slot canyon radiates orange light. Flash floods have sculpted these chambers.

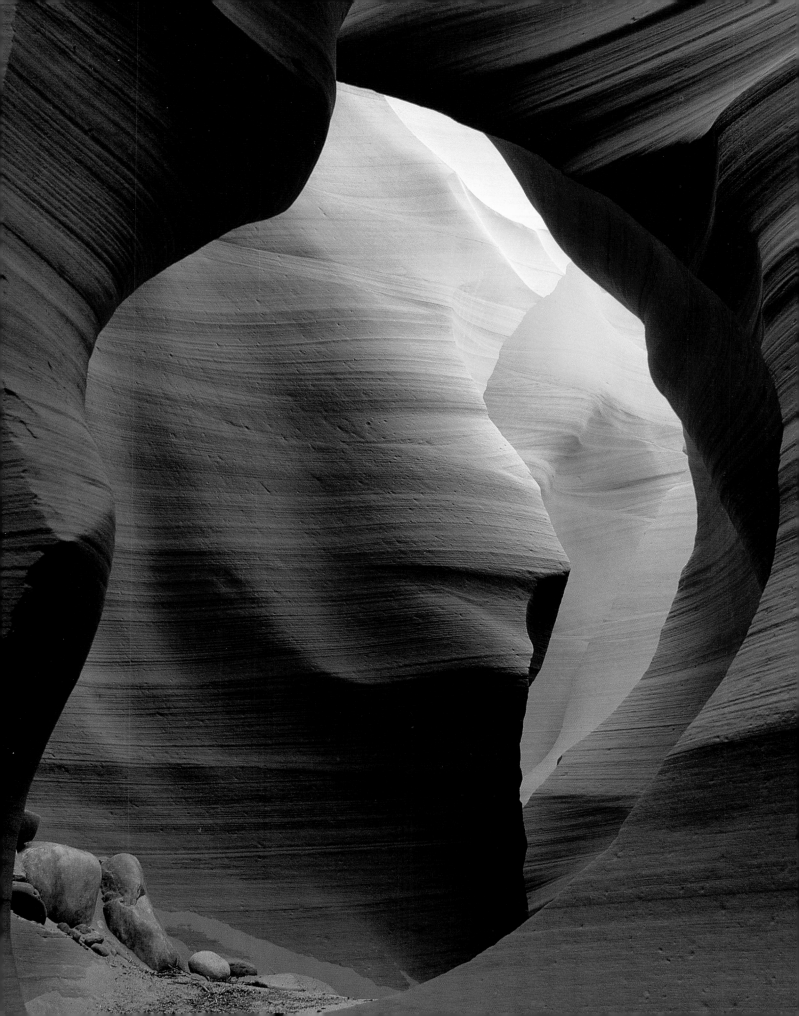

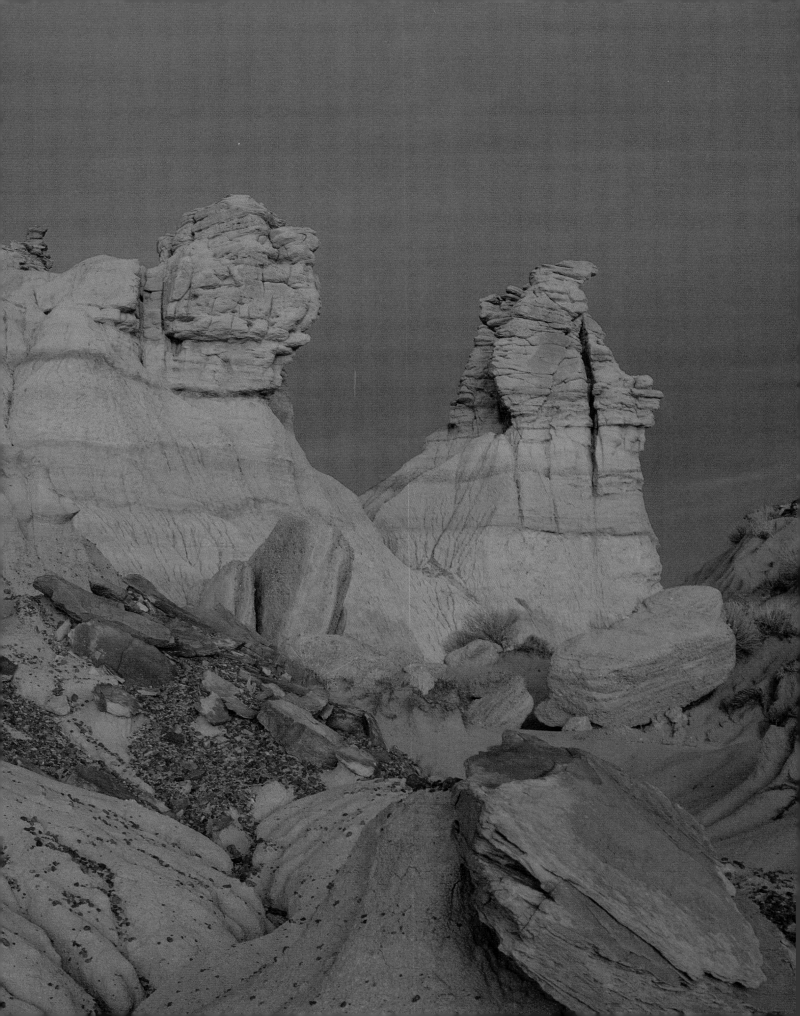

borderlands

They arrived in twos and threes and sometimes alone. If they spoke at all, it was in hushed voices. The pews filled as slowly as water percolating through porous rock. Indians, Anglos, Hispanics, and those with ties to all three found their places in the old Misión San Xavier. An old rancher with a twisted suspender walked past and sat next to two young Indian women. He placed his cowboy hat beneath the pew and waited for Sunday Mass to begin. A young Mexican father, leading two little boys by the hand, leaned over and reminded them to cross themselves.

I had returned to southern Arizona to look for remnants of the Spanish heritage that runs deep in the character of the region. Misión San Xavier del Bac on Tucson's desert fringe was the natural place to start.

Father Eusebio Francisco Kino first visited an Indian village here in 1692, and eight years later, he laid the foundation stones for a church that was never finished. The Franciscan Brothers constructed the present church in the late 1700s to serve the Tohono O'odham Indians.

"The wonderful thing about San Xavier," anthropologist James Griffith enthusiastically explained to me, "is that it's still all there after all the centuries. It's not a museum. It's a living, breathing, changing church."

Enclosed by thick walls that reflected the dim glow of hundreds of candles, the chambered interior felt subterranean, cavernous. Grim saints stood watch behind the altar, filling niches in a wall embellished with a profusion of ornamental detail. It appears not to have been carved by hand but to have been deposited, drip by drip, over the centuries. The faded baroque vision of the cosmos crowded the walls and domed ceiling, but the message of suffering and redemption had endured.

Even with its gallery of saints and angels, San Xavier would have remained hollow without the human voice. The prayers of the priest filled the vaulted chamber with the exact timbre needed to complete the architecture. He lifted a gold communion cup in one hand and a desert-brown Papago basket holding the host in the other. When Mass ended, people pressed down the aisle to the doorway. Joining them, I passed through the massive wooden doors and noticed an iron handle that was wrought in the form of a snake. Placed on the threshold, it gave a warning, but of what I wasn't sure. The Indian food booths across the plaza were selling fry bread and burros—beans or meat wrapped in a large flour tortilla. Father Kino had not only brought Christianity to this land that would someday become Arizona, he also introduced wheat and beef. The diet of the region was never to be the same again.

Before heading into the city, I wanted to see some of the country Kino had crossed. Time after time, the black-robed padre had turned into the unknown desert, eating little, sleeping on a horse blanket, and riding so hard and long that tough frontier soldiers had trouble keeping up. He explored new territory, baptized Indians by the thousands, and established a chain of missions in Sonora, a state in northwestern Mexico, and Arizona.

I headed down the road into the blank light of morning. The highway cuts west through a mesquite thicket where the jointed arms of the chain-fruit cholla look more arachnid than cactus. As I turned south at Robles Junction, a roadrunner crossed the highway with its head stretched forward and its tail pointing straight backward. When I have been away from the Sonoran Desert for a while, I am always surprised by the abundance of life that is found here.

A few paloverde trees had burst into yellow flowers, and a scattering of saguaro cactus poked green arms above the trees. Grama and blue-stem grasses increased as the road followed the gentle rise of the Altar Valley. To the west, a ridge of mountains cuts the skyline like an open jaw. At the far end rises the incisor peak of Baboquivari.

◄ *The Chinle Formation has eroded into fanciful badlands at Blue Mesa in Petrified Forest National Park.*

borderlands

I took the turnoff to the old mining town of Arivaca and the historic Cruce Ranch, once home to more than seventy-five Spanish mustangs. They descended from horses brought in the late 1800s from the Misión Delores in Sonora, once the headquarters of Father Kino. Their color patterns resembled the horses depicted in Spanish paintings of the fifteenth century. But national wildlife refuge managers felt that the herd did not belong and ordered its removal.

At Arivaca, I followed a dirt road that led toward the border and the Pajarita Wilderness. It hugged the dips and twists of the topography of the foothills, steadily climbing into the heart of the mountains. Emory oaks dotted the lower hills, mixing with manzanita and juniper in the higher country.

The ruins of an old adobe house marked the head of Sycamore Canyon. I parked and started down the trail at a quick pace to reach the border and get back by dark—about twelve miles. Rough cliffs and eroded rhyolite pillars formed the rim. Water flowed along the canyon bed, sometimes sinking beneath the gravel, sometimes pooling in bedrock pockets, but always giving life—sycamore trees, live oak, and juniper.

To bypass several deep pools, a little climbing was required, and one pour-off formed a barrier to cows drifting up canyon. Beyond it, I passed cattle trails that pushed through the brush in directions I did not want to go. It was quite reassuring to find that we had different interests.

Although it was the heat of day, shaded turns of the canyon came alive with birds. A particularly graceful one with a long, copper tail sat on a limb watching my approach. It was a trogon, a Central American species rarely seen in Arizona.

A few more bends of the canyon brought me to the Mexican border. Saguaro, ocotillo, and creosote covered the foothills. A very faint trail climbed a ridge overlooking the international boundary—a good lookout. I wondered about smugglers, but I had heard they rarely use Sycamore Canyon because it's too rugged. Many backpack across by easier routes; some use pack horses. Tired of repairing fences cut by smugglers, ranchers along the border have put in gates.

A four-wire fence marked the border—no signs, no flags. I climbed over it and stood in Mexico, an illegal alien for a few moments. On a map, each country has its own color and a thick boundary line. Here, it was different.

The border passed through the middle of a giant sycamore tree. Half the trunk was rooted in Mexico, half in the United States. The wash on one side of the fence was as dry as the other. I wanted to see what had destined this region to be divided into separate destines, but, standing at the borderline, all I saw was a boundary as thin as barbed wire.

The next morning, I parked on a back street in the El Presidio Historic District of Tucson and began to walk. No matter how many times I return to downtown Tucson, I always feel slightly disoriented. It is hard to redraw a mental map. I first walked here before the massive urban renewal of the 1970s. Things have changed. A stranger has an advantage, taking the city as it is given. I walk through neighborhoods long buried, down streets that no longer exist.

In a city of seven hundred thousand, only 15 percent of the population is Hispanic. For many residents, the Hispanic heritage of the region only goes as far as the dinner plate—enchiladas and tacos and burritos and tostadas with a mariachi band to set the mood. But for half its history, Tucson was a Spanish and Mexican frontier post. The Spanish legacy continues to lie close to the soul of the city.

Before Anglo-Americans entered the region in large numbers during the mid-1800s, the Hispanic population never numbered more than one thousand people. Most lived at Tucson or in the presidio of Tubac, since outlying ranches and mines had been overrun by the raiding Apaches. Tucson itself fought off nine major Indian attacks.

borderlands

"It was a desperate struggle for survival," commented James Officer, an authority on the Hispanic Southwest. "What's amazing is that they did survive." Foundations of the old presidio wall lie buried beneath modern streets. A sign at the corner of Church and Washington, in both Spanish and English, marks the presidio's northeast corner. When archeologists excavated this street corner in the 1950s, they discovered remnants of the presidio's old adobe wall. It once stood twelve feet high and ran for seven hundred feet on each side, enclosing plazas, chapel, cemetery, stables, and living quarters for the soldiers and settlers. The foundations of the city literally rest on a Spanish past.

But Arnold Smith, whose ancestor commanded the presidio in the 1830s, told me that the Hispanic heritage of the city is dying. The old cemeteries have been desecrated; the old neighborhoods, leveled. It was time, he stated, to take their history into their own hands.

Urban renewal had replaced worn-out barrios with government buildings that now tower above restaurants and bars where lawyers do business. Galleries, shops, and homes in a mix of architectural styles line the back streets. Some old adobes were remodeled long ago with ornate Victorian gables and porches, while typical American-style houses add a few Spanish touches. I had trouble telling where one influence ended and another began; from the look of things, so did the people who lived here.

From the very beginning, the city has been a place where different ways of life have blended. At first, I was surprised to learn that Tucson residents turn out in force on Saint Patrick's Day to celebrate the city's founding as a Spanish fort.

But spend a little time here, and it will begin to make sense. In 1775, Lieutenant Colonel Hugo O'Conor, a failed Irish rebel turned mercenary commander in the Spanish army, marked out the site for a royal fort that has become today's modern city. A knot of cultures lies at Tucson's heart. That's where it draws its strength. Continuing south across the old Plaza de Armas, I passed homeless men lounging under shade trees where Spanish soldiers once drilled. I walked south across parking lots that covered streets I used to avoid at night. We bulldoze a rough-edged past, keeping an old house or two as a memento to draw tourists, then recreate it in our own image.

West of Tucson lies the Arizona-Sonora Desert Museum, the famous living museum of desert plants and animals. Nearby is a movie studio called Old Tucson. Tourists crowd into streets lined with false-front buildings to see staged gunfights and to watch the dance-hall girls. For most, Old Tucson has become the city's real history, not the run-down neighborhoods once inhabited by Mexicans, Chinese, and maybe an Irishman or two.

Leaving the renewed city, I entered the Barrio Historico District. Rows of adobe houses here have a strong Sonoran flavor: flat roofs, deep-set doorways and windows, thick walls. Some were remodeled into offices and restaurants; others served as homes. As I walked around the block, I noticed a shrine set back from the street. A niche in an adobe wall held votive candles; more stood in wrought-iron candle racks. This was the wishing shrine of El Tiradito.

Legends have grown about the shrine over the years. Most tell of a young man murdered in a tragic love affair. Being a sinner, he was buried where he fell. He is said to intercede for those who stand vigil through the night or leave a burning candle in their place. Some pray and leave offerings. One must have walked home barefoot; a pair of boots sat on a shelf above the niche.

Wind had blown out all but one candle. A flame flickered in the bottom of a glass. The adobe wall behind it was smoke darkened; the ground in front, saturated with generations of melted wax. Despite all the changes since Father Kino first rode north, someone had not given up hope. One candle still burned in the heart of the old city.

cliff dwelling

The guide ordered us to dismount and lead our horses down a rough trail that dropped out of sight below. We had reached the rim of Canyon del Muerto, the canyon of the dead. The other horses started the descent, but mine wasn't budging. She knew what was ahead. I looked that horse straight in the eye to let her know who was boss, but the bluff didn't work. I had never realized before how big and inhuman a horse's eye could be. Not knowing what else to do, I gave a yank on the reins, and the horse started to walk. Hiding my surprise, I followed the others, trying to look like I knew what I was doing.

The party wound its way down into the northernmost of the three branching gorges that form the Canyon de Chelly National Monument. Ron Izzo, head of the Navajo tribal rangers, had the lead. Although not an Indian, he had grown up here and married into a Navajo family. Leroy Yazzi brought up the rear, leading the pack horse. In between walked a group of friends, each coaxing a reluctant horse.

As we descended Twin Trail, the red sandstone extended in dramatic cliffs to the canyon floor below. Each fold in the wall held a small ruin that was in the process of slowly being absorbed by the passing centuries.

The trail dropped steadily for the first mile before leveling off where it skirted Navajo fields on the canyon floor. We stopped to regroup in a fringe of Fremont cottonwoods bordering Tsaile Creek. It was easy to see why people had chosen to live here, generation after generation. Water, trees, grass, fields—all contrasted with the harsh plateau country we had left behind.

After a short rest, we began the long ride up canyon. My horse kept looking back until the trail leading home was out of sight. It had been years since I had been on a horse, but Izzo had insisted it was the only way to really see the canyon. Not totally convinced, I was willing to put up with the horses only as a means to reach the more remote country.

We followed the clear waters of the creek that in a few weeks would sink beneath the wash as the heat of summer grew. The string of horses trailed between cross-bedded cliffs rising a thousand feet on each side. Dark stains of desert varnish spilled down the smooth walls. The pure, uniform sandstone had formed from dunes that had been blown by winds from the north two hundred million years ago. Each twist of the canyon disclosed more ruins perched in the hollows of the rock high above the flood-plain. Some had been lived in, but most had been used as granaries to store crops. The prehistoric Anasazi Indians had farmed the canyon bottoms, growing cotton, beans, squash, and corn.

They stored whatever they could for the winter months. One excavated storage cist held a cache of seven hundred ears of dried corn that was still brightly colored. But corn was not the only thing the early Anasazi storage bins held. Some contained burials—mummies that had been naturally desiccated by the dry climate of the region.

Passing a tall rock spire known to the Navajo as the Wolf, we reached Big Cave, a rock shelter that sprawled more than a thousand feet along the base of the cliff. We rode close enough to see pictographs painted on the far wall but did not enter the fenced-off ruins.

Archeologist Earl Morris uncovered a mysterious burial here in the 1920s. In one compartment of a storage room that was divided into quadrants, he found a pair of hands and forearms. No other parts of the body ever turned up. Two pairs of sandals, beautifully woven in red and black patterns, had been placed on the upturned hands. On top rested three shell necklaces. The archeologist never came up with a satisfactory explanation for the strange burial.

Two of the other compartments were empty, but the mummy of an old man lay in the fourth. With him had been interred four wooden flutes in perfect condition.

cliff dwelling

Tributary canyons branched east as we continued up the main gorge. We moved at a steady pace, falling into the rhythm set by the horses' gait. Several miles above Big Cave we topped a sandy ridge. Reining in the horses, we caught sight of an ancient stone village on the far side of the canyon. Pressed beneath overhanging rock hundreds of feet thick, the tiered houses appeared to be carved from the cliff face. A three-story tower stood at the center of the site overlooking a warren of seventy rooms. Seen at a distance, it had a floating, miragelike quality. This cliff dwelling awakened a vague longing in me. For what, I wasn't sure. Perhaps it was a longing for a life closer to bedrock.

His black cowboy hat pulled low, Izzo leaned sideways in the saddle, looking back over his shoulder as he talked. "That's Mummy Cave," he pointed out. "The Navajos call it *Tse'yaa Kini,* 'House Under Rock.'" Naturally mummified bodies that were discovered here by a Smithsonian expedition in the 1800s gave the canyon its name.

Anasazi lived in Mummy Cave during a thousand-year span of their history. They arrived about A.D. 300, long before they had learned to make pottery and use the bow and arrow. Only after their population peaked in about 1150 did the Indians begin to construct large cliff dwellings. The square tower may have been the last structure that was built in the canyon; its timbers were cut in 1284. By 1300, the cliff dwellers had abandoned the region.

Some archeologists believe the end came when an over-exploitation of natural resources led to an environmental crisis. Clear-cutting trees from the surrounding plateau triggered huge floods. But the old Navajo say fire destroyed the Anasazi as punishment for trying to learn more than the body of knowledge given to them. Like the people today, they add.

We rode closer to the ruin and tied up the horses. The peculiar sway of traveling horseback lasted even after I had dismounted. Stretching my legs, I realized that the cowboys have it wrong. A novice is not a tenderfoot. After a few hours in the saddle, it definitely is not your feet that get tender.

Needing to cover several miles before camp, we pressed on after a short rest. Not far up canyon, Izzo pointed toward the cliff face high above. "Massacre Cave," was all he said. Little could be seen from below; we easily could have ridden past without suspecting its location.

In 1804, Spanish soldiers wearing their dark winter cloaks rode up canyon with muskets poised, looking for Indians. They might have kept going, but a former Spanish slave was unable to restrain herself. High above the soldiers, she shouted an insult that gave away the hiding place of almost a hundred women, children, and old people.

The main Spanish force blocked escape while snipers took up positions on the rim. They fired into the cave, ricocheting bullets off the ceiling into the people. Few remained alive when soldiers climbed to the overhang to finish their work.

These canyons remained the last stronghold of the Navajo before the U.S. Army drove them out. In 1864, Kit Carson, the famous scout, sent cavalry detachments into the deep gorges. The Indians gave only token resistance as the troopers swept through, burning crops and cutting peach trees.

"Every time the soldiers saw a sheep," said Izzo, "they would shoot it; every time they saw a cow, they would shoot it; every time they saw a horse, they would shoot it; every time they saw a field of corn, they would burn it; if they saw a fruit tree, they would chop it down." By spring, the people were starving and began to turn themselves in to the military.

"Word spread that the soldiers had penetrated the canyon," Izzo said, "something the Navajo thought they could never do. People began to surrender by the hundreds and eventually the thousands." Every refuge becomes a trap in the end.

On a stretch of sand, several riders decided to give the horses free rein. In a sudden burst, we galloped up the trail.

cliff dwelling

Hooves barely touched the ground, carrying us along in a surge of power. Speed was visceral. It was felt in every cell, as if the riders were running, not the animals beneath them. A long half-minute later, we settled back to a walk, as if nothing had happened. By now, I was feeling stiff, but no matter. I was enjoying the ride too much. The horse has been linked with this landscape for so long it felt right, a part of this way of life. Late in the afternoon we reached an old sheep camp belonging to Izzo's relatives. An abandoned hogan stood in the trees where we unsaddled the horses. There was still time to look around.

Scrambling over boulders, I made my way up a side canyon. About to return to camp, I spotted a ruin perched on a high ledge. There was no obvious way to reach it, but I wanted to try. Traversing along a steep sandstone face, I noticed a line of shallow handholds pecked into the rock leading upward. I began to climb. One or two had weathered away, but the others gave enough friction to get to a higher ledge. I followed this until I came to an old log propped against the next cliff. It held, and I finally reached the broad shelf leading to the ruin.

Roofs had collapsed, but many of the walls still stood. I stooped through a low doorway into a jumble of rooms that seemed too small and too compact—more like the wreck of a ship than the ruins of a village.

Footprints had been pecked into the ledge centuries ago to mark the best route. On the far wall stood a petroglyph of a masked figure holding arrows; nearby were red prints of hands that once had been pressed wet against the rock. The rooms were not well preserved, but normally perishable material, like corncobs and yucca cordage, littered the site. A shovel rested in the corner of one room where someone looking for pots long ago had dug a shallow pit and stopped.

Sitting on the cliff edge and looking down canyon, I knew that the people who once lived here were not total strangers.

I could understand something about them simply by the place they had chosen to live in and the homes they had built for themselves—the stark geometries of need translated into stone. The simple desires that moved them still move within us—the warmth of the morning sun, a nice view, a dry place to sleep, human companionship, and something else.

The maze of rooms hidden high on a remote cliff stood empty but not abandoned. Those who once lived here had left centuries before, but their feeling for beauty remained. Indians who had stacked these rocks into multistoried houses had lived within the graceful lines of a canyon scaled to a human dimension. The landscape had not overpowered their way of life.

The Anasazi built small communities that harmonized with the natural beauty of cliff and stone. Years of weathering had only enhanced this bond, blending house wall with cliff wall. Although village walls would fall before canyon walls, the effort had not been futile. There was no sense of loss here, only of completion. One cycle had ended; another, begun.

As I sat listening to a breeze move through the cottonwoods below, a canyon wren called nearby. The clear notes tumbled down a scale older than the Anasazi flutes of Big Cave. During the ride up canyon I had wondered how one of the old instruments might sound. They would have been keyed to the chants used in their ceremonies, the way Pueblo Indian flutes are today. To hear one would be to hear the sound of the human voice from long ago. Archeologist Earl Morris had heard that sound.

After uncovering the flutes that had not been played in a thousand years, he picked one up, put it to his lips, and blew. "Rich quavering tones . . . seemed to electrify the atmosphere," Morris wrote. Navajo crew members stopped their work and listened. A horse raised its head, and two ravens flew from a crack in the cliff above. It was as if the strange notes echoing from the cave had turned back time.

mountain roundup

The herd was on the move in the gray light of early morning. Horsemen bobbed above the mass as the tightly bunched cattle pushed forward. I ducked behind the corral fence to keep out of sight and avoid spooking the cows. It was branding time. Roundups, I thought, were supposed to be whoops and waving hats, clouds of dust and snorting animals. This was different. Riders driving the herd seemed to sense when a cow would break for timber. They worked their horses into a blocking position before the cow could bolt, doing more with their eyes than with their ropes.

The cows were Herefords; the trucks parked at the corral, American made. Exotics don't catch on here. It's immaterial whether it's hybrid cattle, imported trucks—or insects.

Earlier, I had stopped at a cafe on the edge of town. A group of ranchers was having its morning confab around two tables pushed together at the end of the room. A cowboy next to me stared into a cup of coffee, nursing a hangover.

Something moved across the floor. "What's that," said one of the men at the far table. Turning to look, I saw a huge insect about the size of a mouse ambling along like it had the run of the place. A month before, the newspaper had reported that a new form of African cockroach had appeared in the valley. Before I got a good look, the pointed toe of a cowboy boot stretched out from the next table. As casually as putting out a cigarette, it stepped on the cockroach with a crunch that could be heard across the room.

"What'd you do that for?" someone shouted. "That was meat on the hoof." The waitress walked in to see what the commotion was all about. "Hey, call that cockroach back in the kitchen where it belongs," a rancher joked. Another, still in awe, added, "You could of put a saddle on that one."

The cowboy next to me sipped his coffee. "Terrible way to start the morning," he muttered to himself.

After leaving the cafe, I drove up the mountain to help with the branding. As the herd reached the corral gate, I noticed Pete Michelbach for the first time. Sitting effortlessly in the saddle, wearing a sweat-stained Stetson, the old cowboy was still going strong after eighty-four years on the mountain. Gates were shut behind the herd and about fifty calves were separated from their mothers for branding. A holding pen funneled them, one by one, into a narrow chute. As a calf ran out the far end, a metal bar clamped its neck. Men standing on both sides tipped the animal on its flank. Only Pete did the branding and castrating, using his pocket knife for cutting. Boys watching from the fence wrinkled their noses at the pungent odor of burning fur. A cowboy smiled at them and said, "Elegant smell, ain't it?"

The work continued with few hitches until late morning. When the job was done, one of the hands let cows and calves back into the pasture. "Everyone come up to the house," Michelbach said. He had a side of beef barbecuing at his ranch house on Hart Prairie to feed those who had helped.

Following the dirt road to the Michelbach Ranch, I passed tall stands of ponderosa pine that opened onto high meadows bordered by aspen groves. Pete's uncle had discovered this place on a hunting trip in 1881.

Before reaching the ranch, I pulled to the side of the road and stepped out of the truck. Aspen leaves flickered in a soft breeze. Walking into the grove, I found carvings in the soft white bark. A Spanish sheepherder had cut a cross into a tree; just beyond, another aspen was carved with a peace symbol; and nearby, the words, "HEAVY METAL," scarred a third.

Beyond the trees stood the San Francisco Peaks, reaching 12,633 feet—Arizona's highest point. Named by the early Spanish missionaries, the solitary mountain sweeps upward from a vast plateau, creating a dramatic landmark. Its presence dominates much of northern Arizona. Seen from the south, it rises above the red rock of Verde Valley; from the north, it stands beyond the rim of the Grand Canyon; and from the east, it sits over the Hopi pueblo of

mountain roundup

Old Oraibi. Both Hopis and Navajos consider it sacred and have fought to prevent development.

The mountain's west face, overlooking Hart Prairie, forms a ridge high above the treeline. Humphreys Peak anchors one end; Agassiz Peak, the other. Ski runs lie between them, cutting through aspen and ponderosa on the lower slopes, Engelmann spruce and Douglas fir on the upper. A fringe of bristlecone pine and low mats of dwarf juniper form the treeline, and only patches of tundra grow on the bare rock above.

Weather has reworked the mountain's face, obscuring its volcanic origin. Avalanche chutes and rock slides finger down, covering glacial moraines and lava flows.

Some places, I approach with detachment; others have grown too close. Living at the mountain's base, I no longer see it the way I once did. It has become a composite of geologic epochs, seasons, and events compressed into a single image. A volcano erupts while glaciers grind. Thunderheads boil up from the highest peak as a vortex of snow blows from a cornice. The sound of wind mixes with the grunt of a black bear at night. A hiker's pace blends with a mountain lion's stalk. Antlered elk graze as a Basque sheepherder watches his herd pour over a ridge. Memories build up, layer upon layer, forming an unmapped landscape.

I continued on to an aspen pole corral marking the turn to the Michelbach homestead. Two solar panels stood in front of the main house, sheltered in a stand of aspen and pine. Barn, corrals, and an old log cabin clustered around it.

Women, some who had helped at the roundup, set out pots of beans and other dishes on picnic tables. Men led horses into the corral, handed out beers, and brought out rifles to shoot at prairie dogs. A crew dug the meat from a pit where it had been barbecuing all night; others rolled mountain oysters in flour and fried them until crisp. Calf fries someone called them. After washing up and bandaging a deep cut from his knife, Pete sat down to talk with friends. He wore a cowboy shirt tucked into jeans held up by suspenders. Years of wind and sun had weathered his face into steep ridges cut by a dry wash or two. As a boy, Pete had left school to help his father run the ranch. Over the years, he worked various jobs to supplement ranching. He did maintenance at a nearby military installation and served as undersheriff for a few years, once having to kill a man in the line of duty. But he made sure his children got an education. One became a pharmacist; one, a teacher; the other, a surgeon. "The one thing I regret," he said, "was never getting an education."

Michelbach spent spring through fall on the mountain, wintering near Sedona. "We came in the cold and left in the cold," he said. He remembered one October when an early storm dumped two and a half feet of snow, stranding him with a hundred head of cattle. He had to saddle his horse and lead the herd to safety. "There was so much snow they closed the highway," he said. "I broke trail for them all the way there."

When a boy asked how they used to make hay, Pete began to describe the hard, back-breaking work. "You had to handle it at least six times," he said. They mowed the heavy oat hay, raked it into windrows, let it sit for a day, then raked it into sheaves. Next they pitched it into the wagon and hauled it off to stack. After several weeks, they baled it and loaded it on the wagon to take to the sawmill in town. There, they unloaded it and stacked it again. "You're lucky," he said, "plain lucky you didn't have to do it."

Conversation drifted to the collapse of old values, old ways of living. Michelbach told of his problems with outsiders cutting fences and wrecking his corrals. A friend suggested moving, but he said, "No, this is my bailiwick. I'm staying here."

Pete is the first generation raised on the mountain, the last still here. Settlement's ebb and flow is an old pattern. Scattered at the mountain's base are prehistoric ruins, deserted homesteads, old log cabins. It's a hard land to make a living in. There's always reason to leave, but some never do.

▶ *A spring snow dusts the Lukachukai Mountains in northeastern Arizona.*

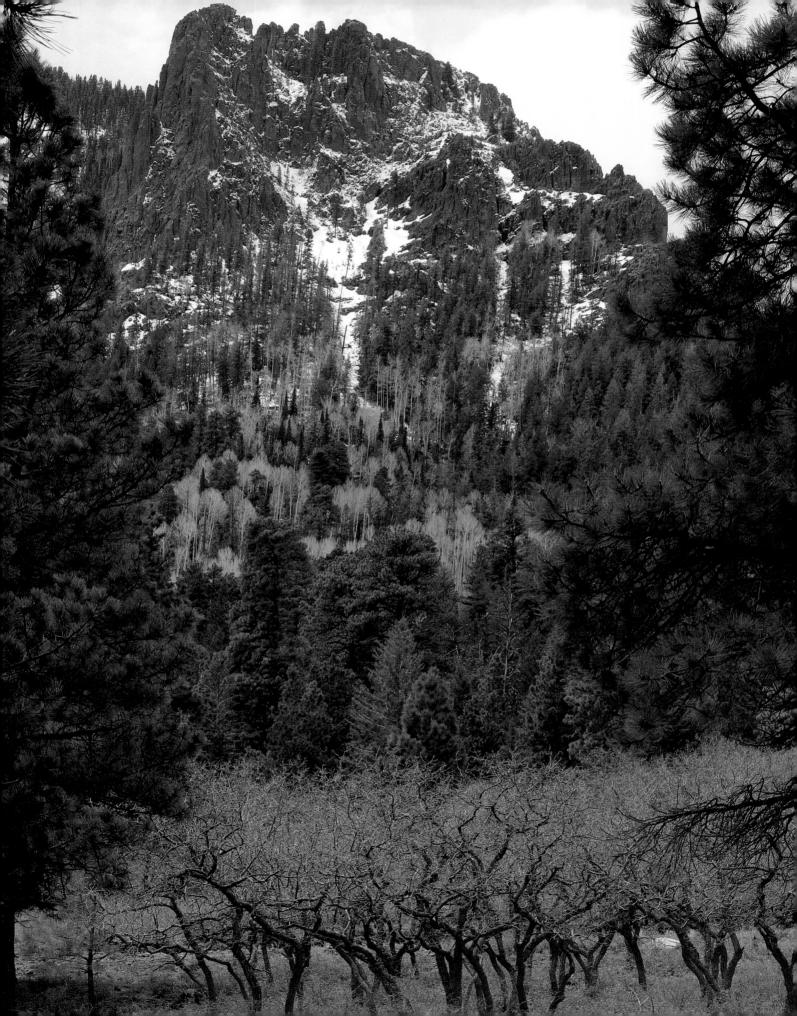

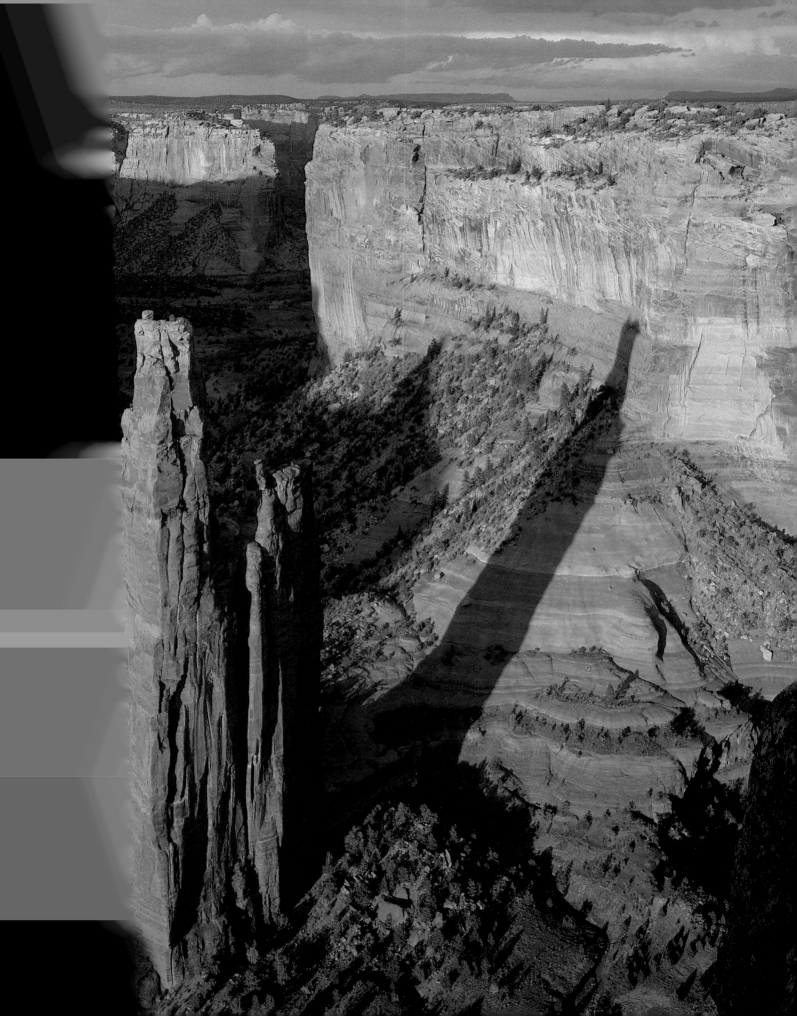

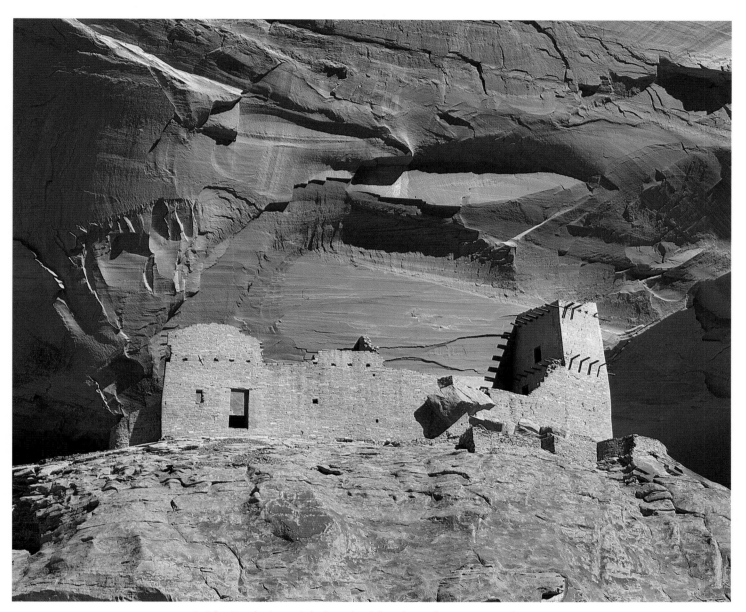

◄ Spider Rock rises eight hundred feet from the junction of Canyon de Chelly and Monument Canyon. ▲ Archeological treasures abound throughout the Canyon de Chelly National Monument. Mummy Cave Ruin is but one of the more than seven hundred ancient Anasazi sites that are preserved in the monument. The Anasazis abandoned the canyons near Chinle around A.D. 1300.

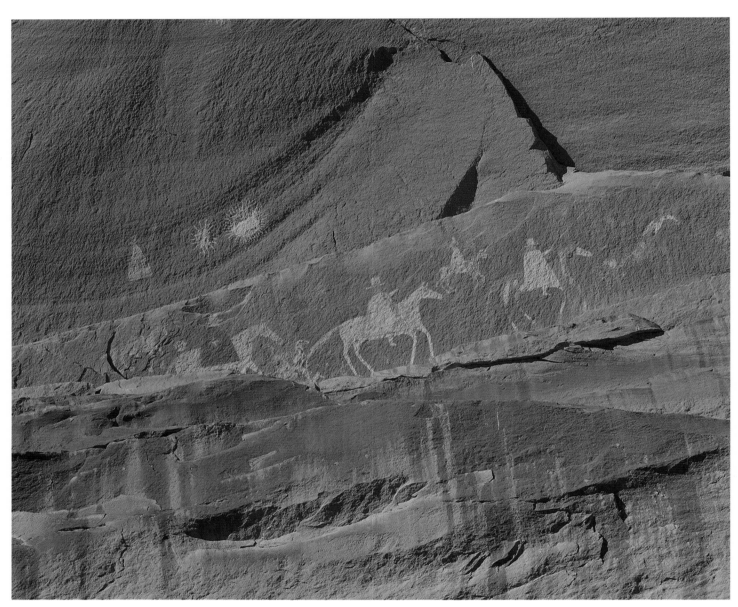

▲ Navajo people now call Canyon de Chelly home. Navajo pictographs that date from the early seventeenth century record the advance of the Spanish cavalry unit led by Antonio Narbona. In the winter of 1805, Narbona led the cavalry into Canyon de Chelly and massacred hundreds of Navajo women and children.

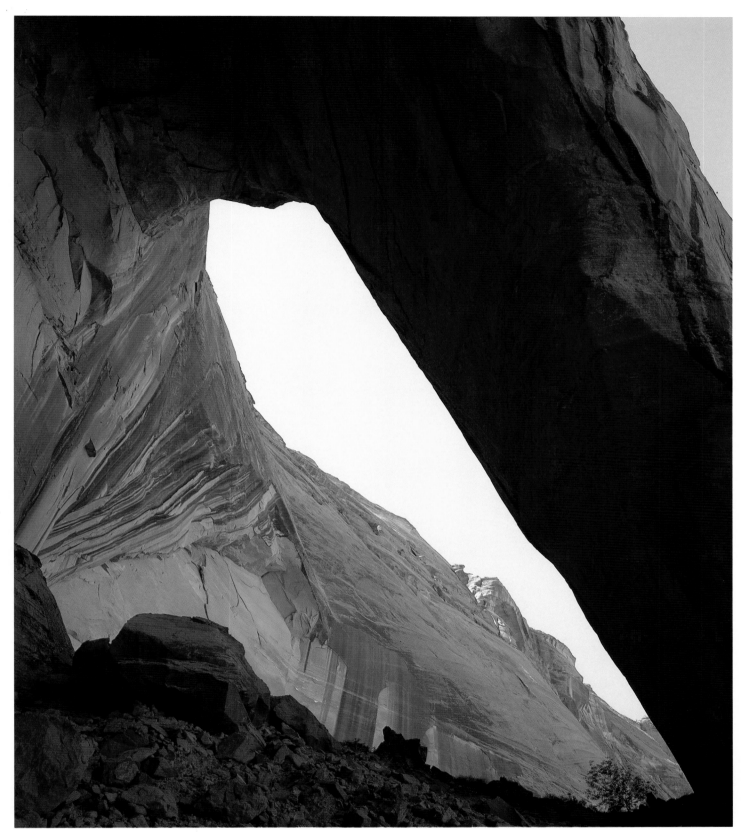

▲ Near the head of Wrather Canyon, an arch awaits explorers Paria Canyon explorers. ▶▶ The setting sun catches West Mitten Butte and a juniper in Monument Valley Tribal Park on Navajolands.

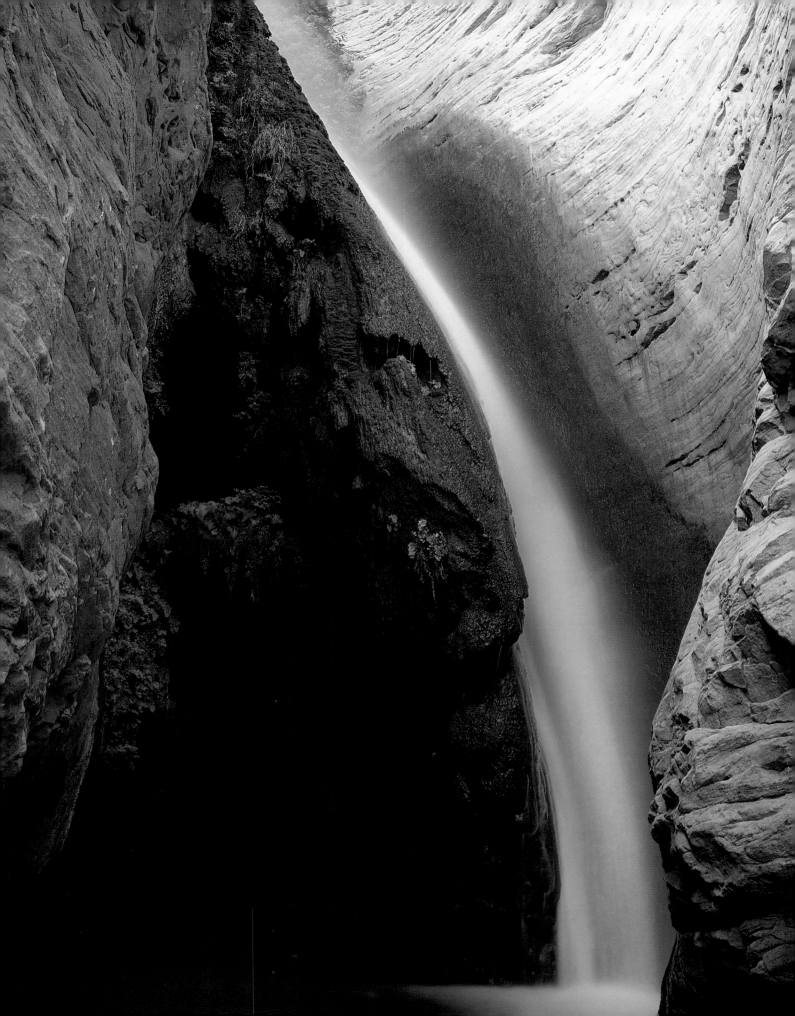

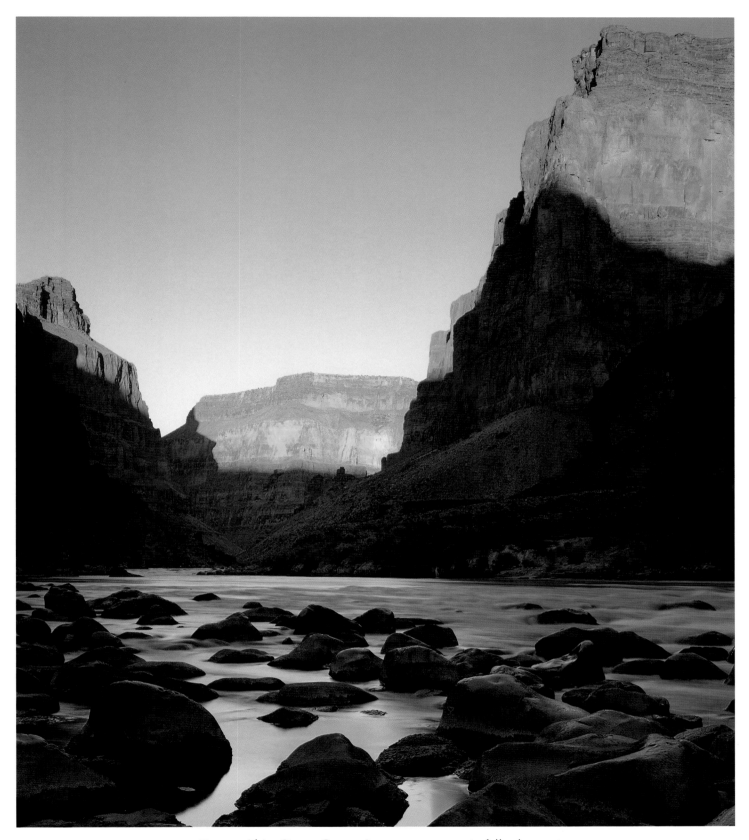

◄ Deep within Stone Canyon's narrows, a waterfall plummets toward the Grand Canyon. ▲ Cove Mesa displays deep canyons, huge monoliths, and stately buttes of the de Chelly Formation.

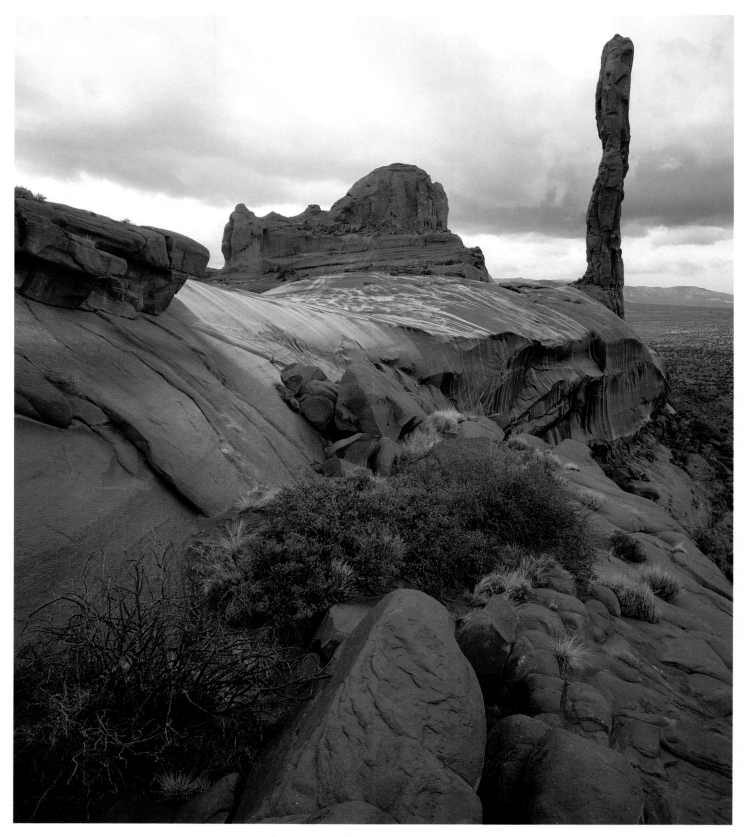

▲ Downstream from Lava Falls, the Colorado River placidly flows past boulders in the Grand Canyon. ▶ In spring, Indian paint-brush adds a splash of red to a slickrock mesa on the Arizona Strip.

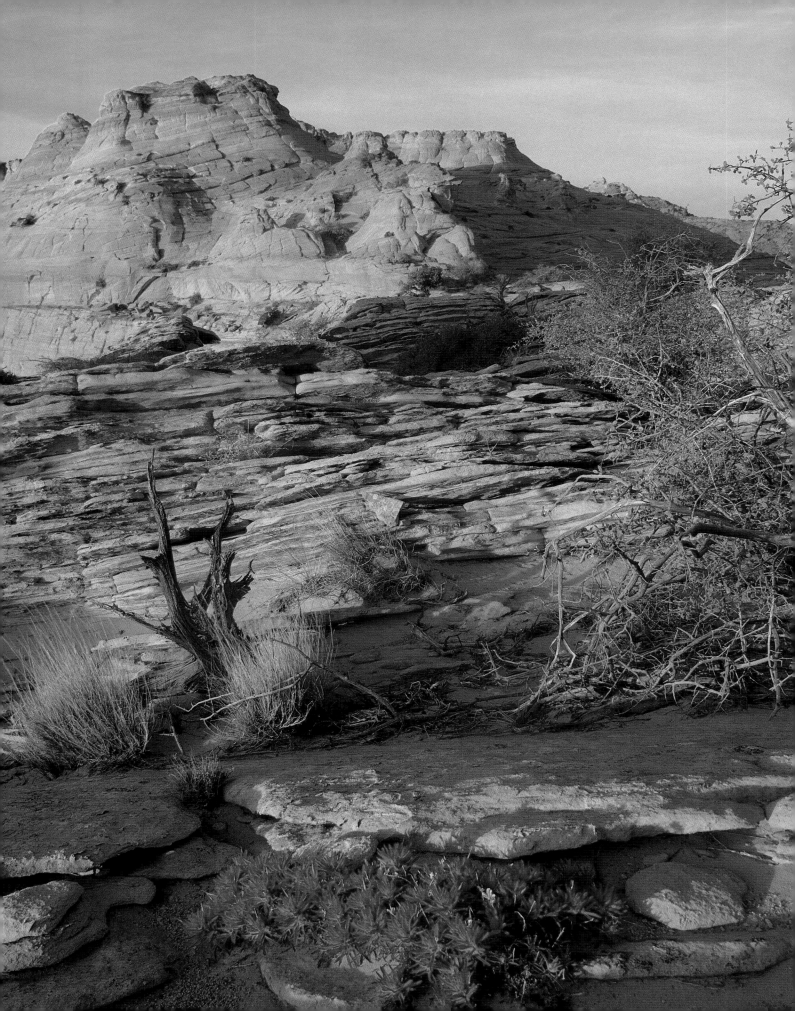

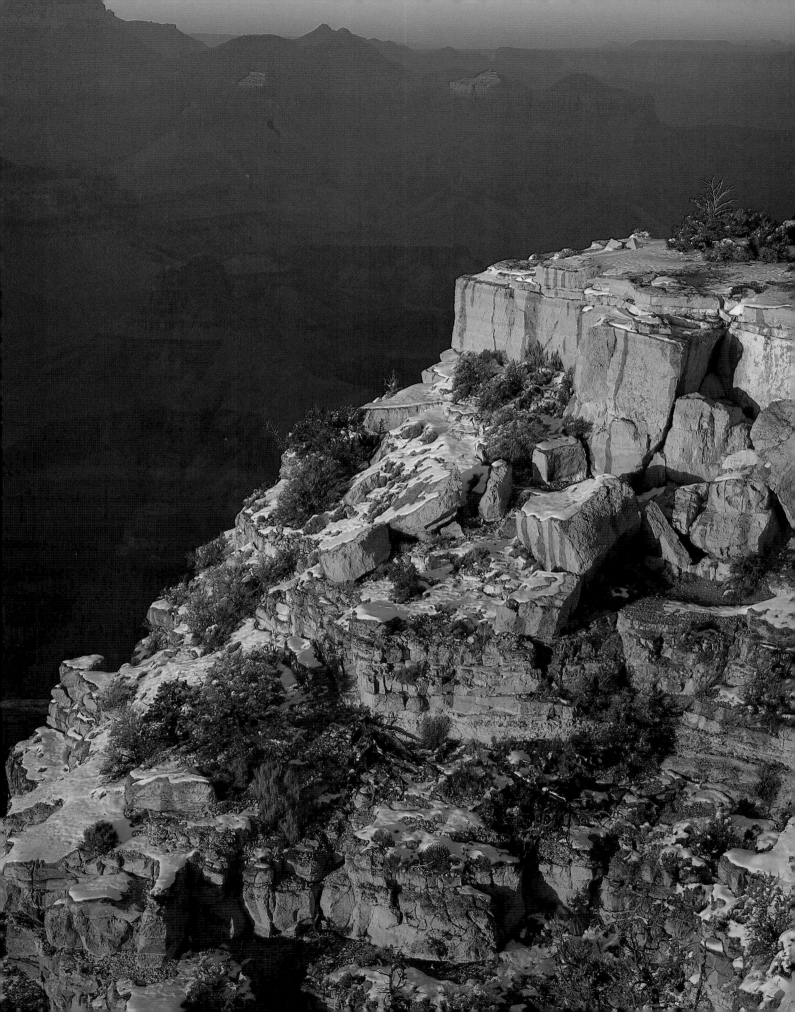

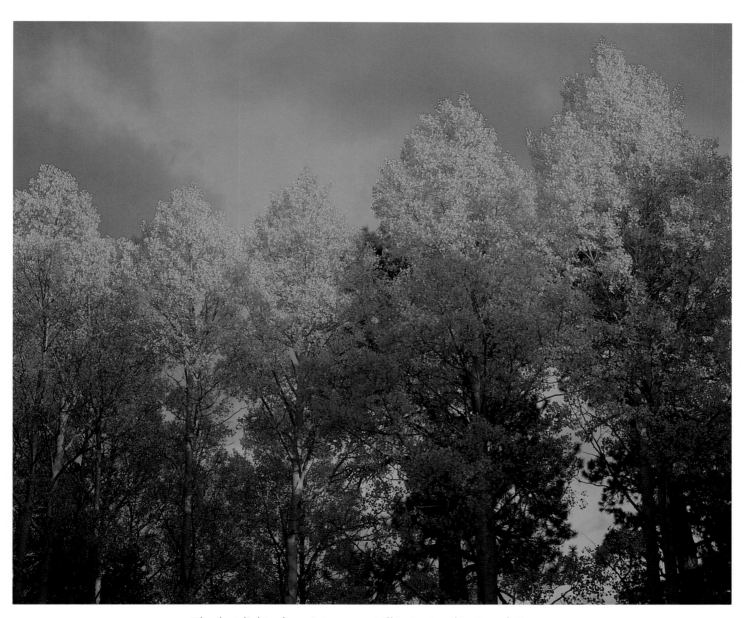

◄ The last light of a winter sunset illuminates the Grand Canyon, viewed from Moran Point on the South Rim. ▲ Aspens catch sunset's fiery glow on the Kaibab Plateau. September is the month that brings the peak of brilliant fall color to the high country.

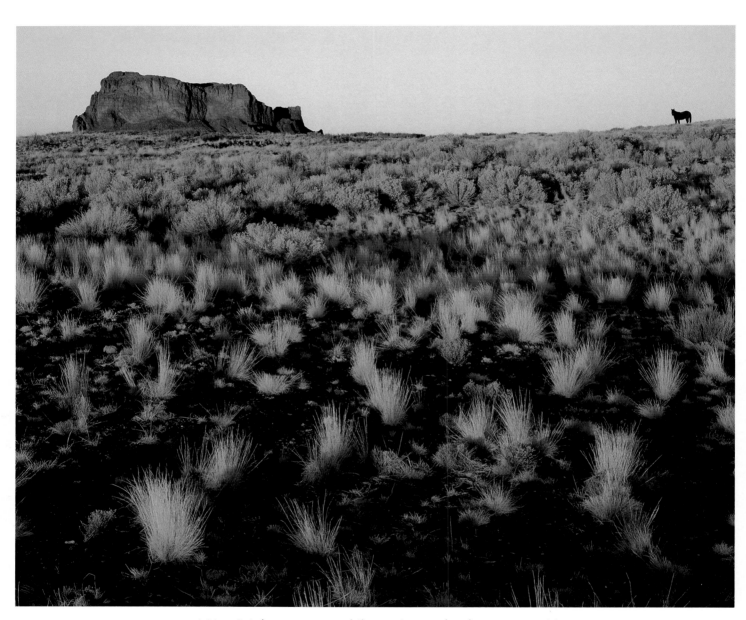

▲ A Navajo's horse pauses while grazing on the short-grass prairie near Bidahochi. Navajolands, which comprise the nation's largest Indian reservation, cover more than sixteen million acres in Utah, Arizona, and New Mexico. ► Desert paintbrush blooms by petrified wood in the Rainbow Forest of Petrified Forest National Park.

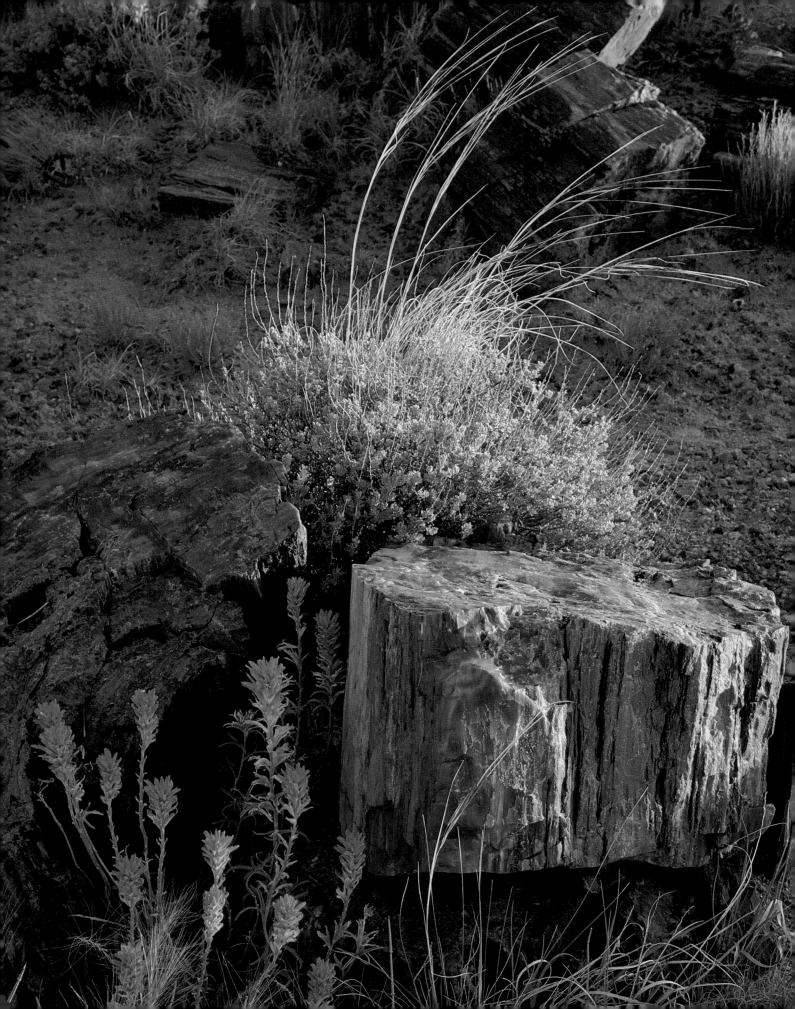

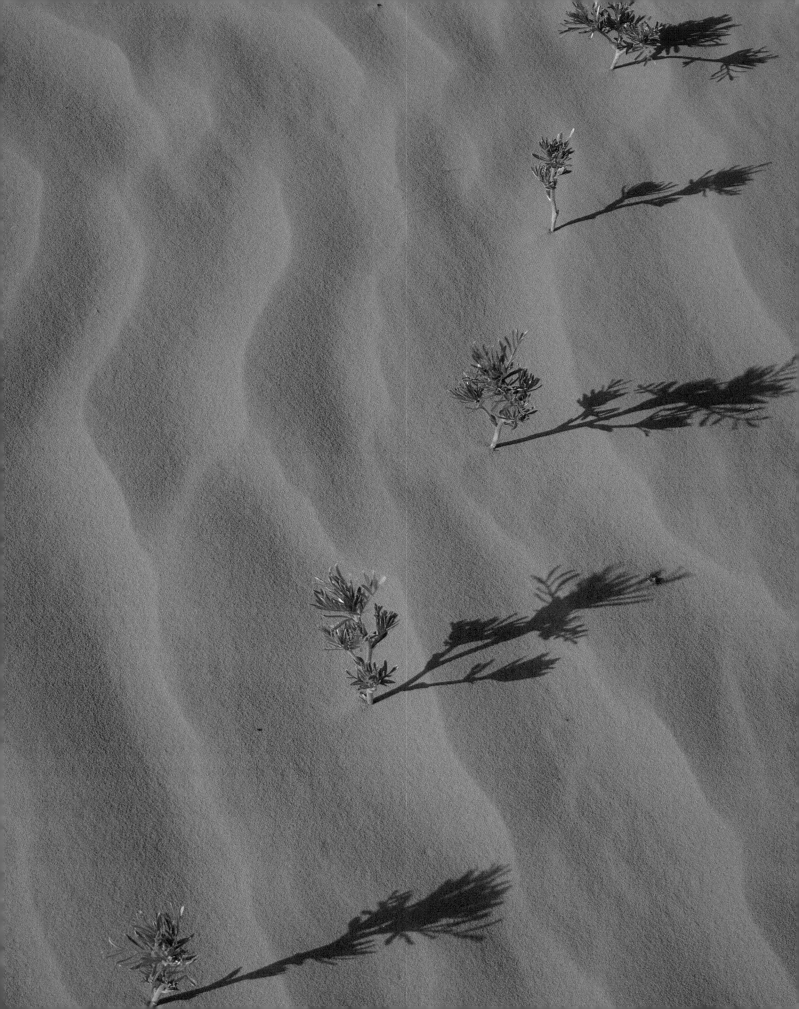

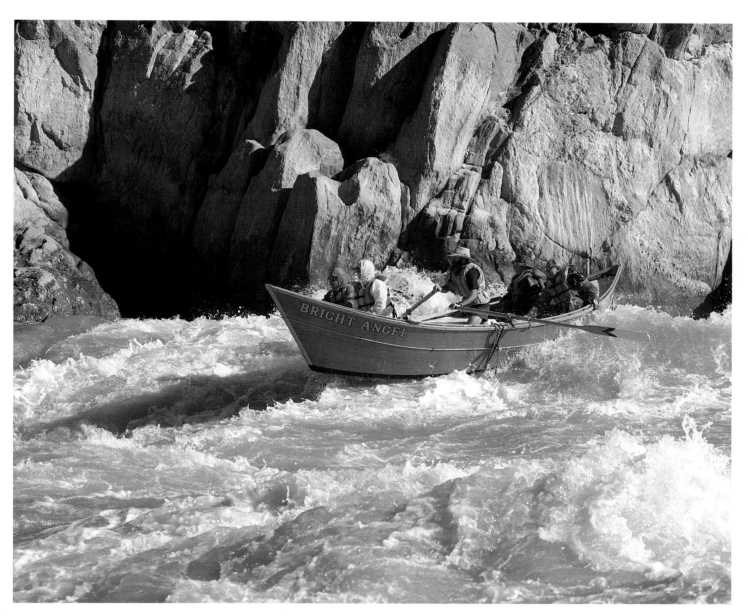

◄ Lupines sprout from a straight-running root beneath a sand dune in Monument Valley Tribal Park. ▲ A Grand Canyon Dories boatman rows passengers through Granite Rapids. Over 160 rapids greet whitewater enthusiasts as the Colorado River drops 1900 feet in the 238 miles from Lees Ferry to Lake Mead. ►► Snow blankets Aspen Lake's shore during May green-up in the Sitgreaves National Forest.

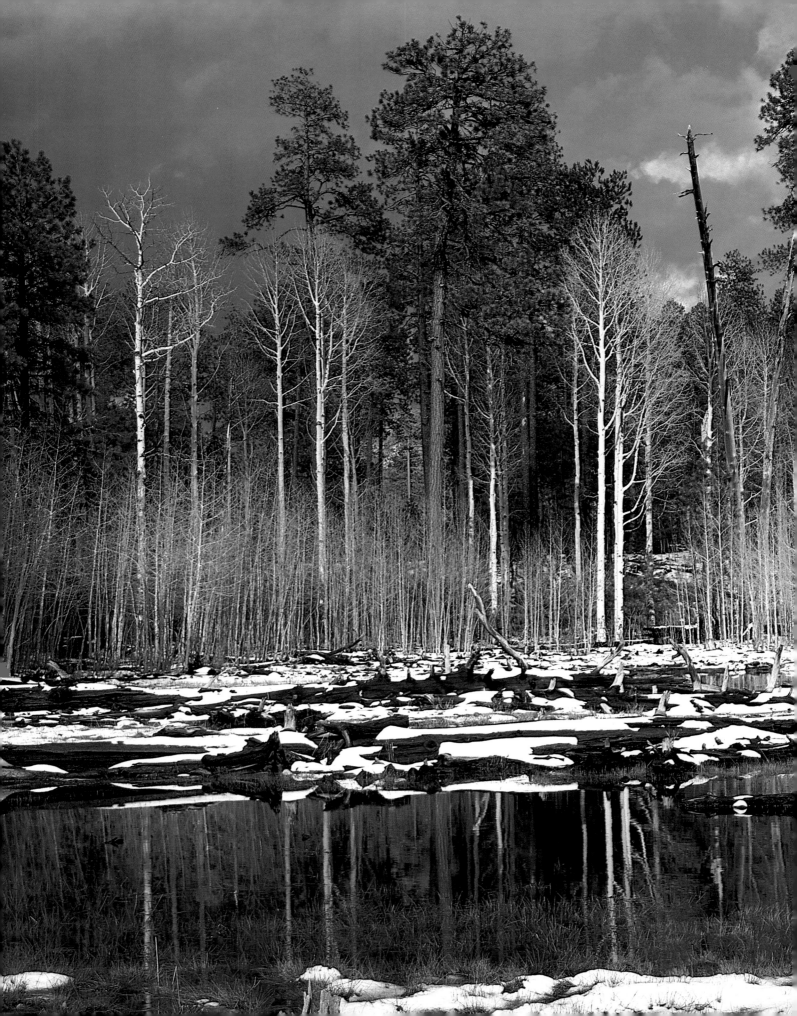

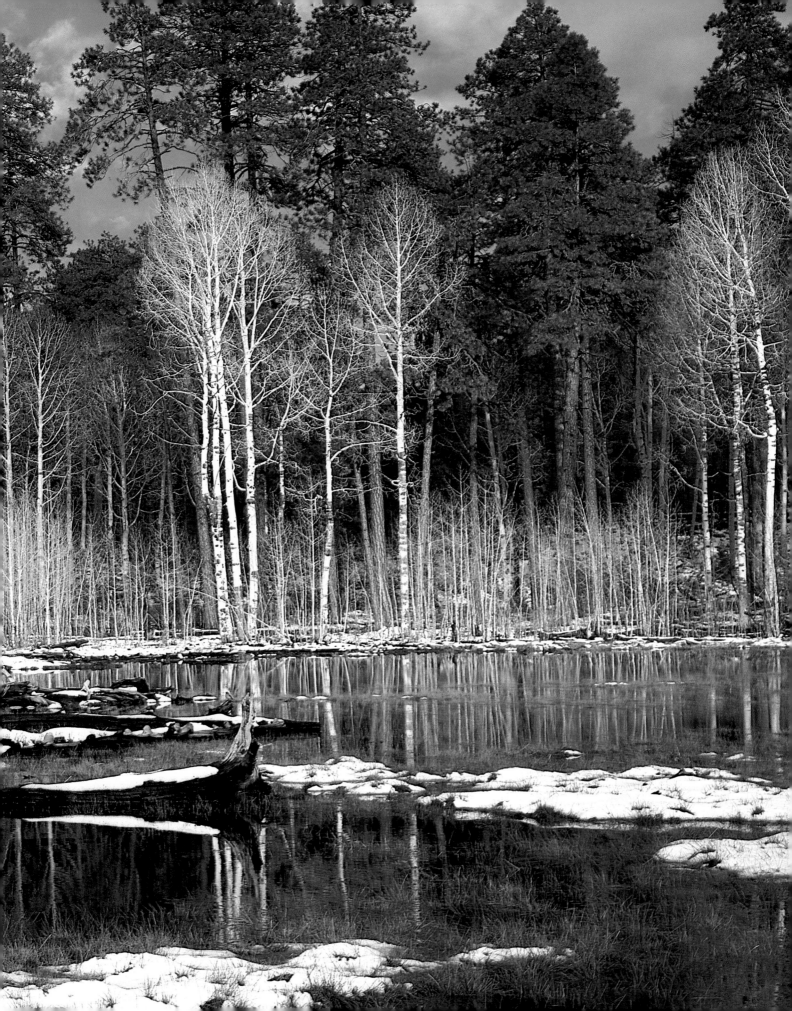

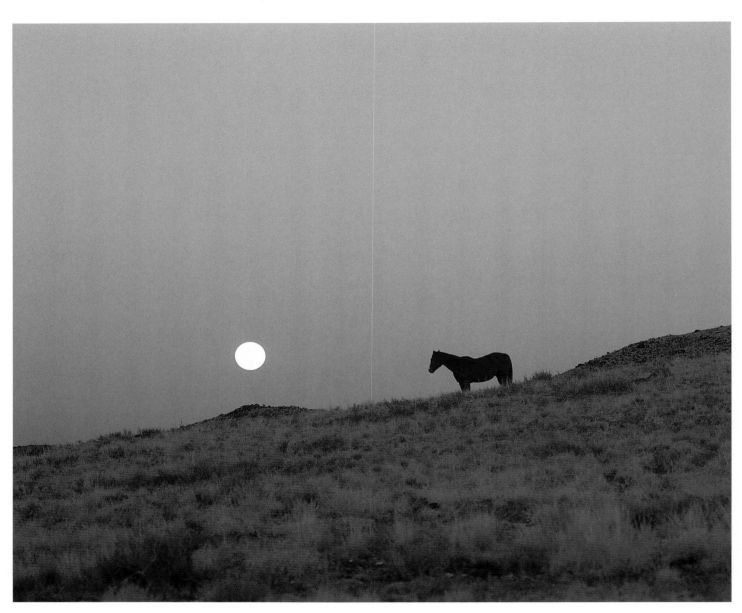

▲ A full moon rises behind a horse on the Navajo Reservation. Horses—which were brought to the Southwest by the Spanish explorers, soldiers, and missionaries who first came in the sixteenth century—were soon utilized by the Native peoples of Arizona.

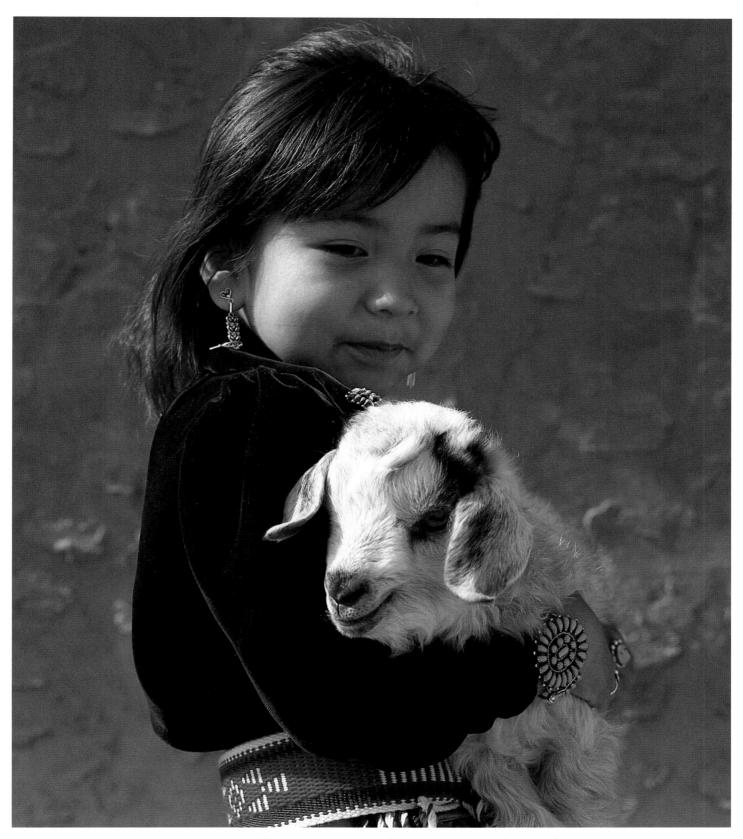

▲ Five-year-old Leatrice Mannie cradles a young goat at her grand-mother's house on the Navajo Reservation near Ganado. Many families run sheep and goats, their wool destined for Navajo rugs.

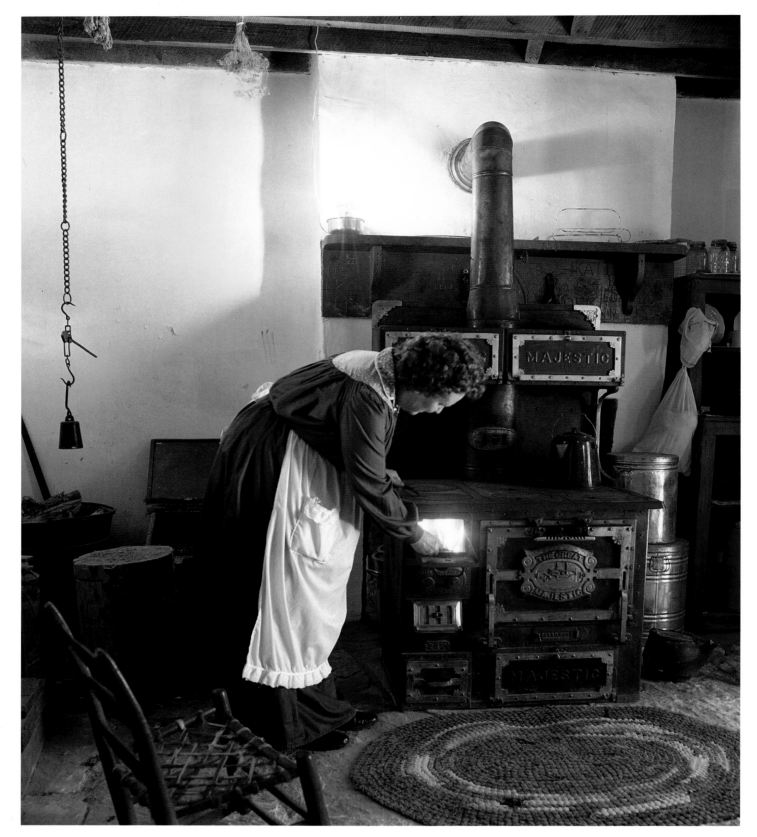

▲ Yvonne Heaton bakes cookies in Winsor Castle as she gives a Mormon living-history talk at Pipe Springs National Monument.
▶ Mary Lee Begay displays her rugs at the Hubbell Trading Post.

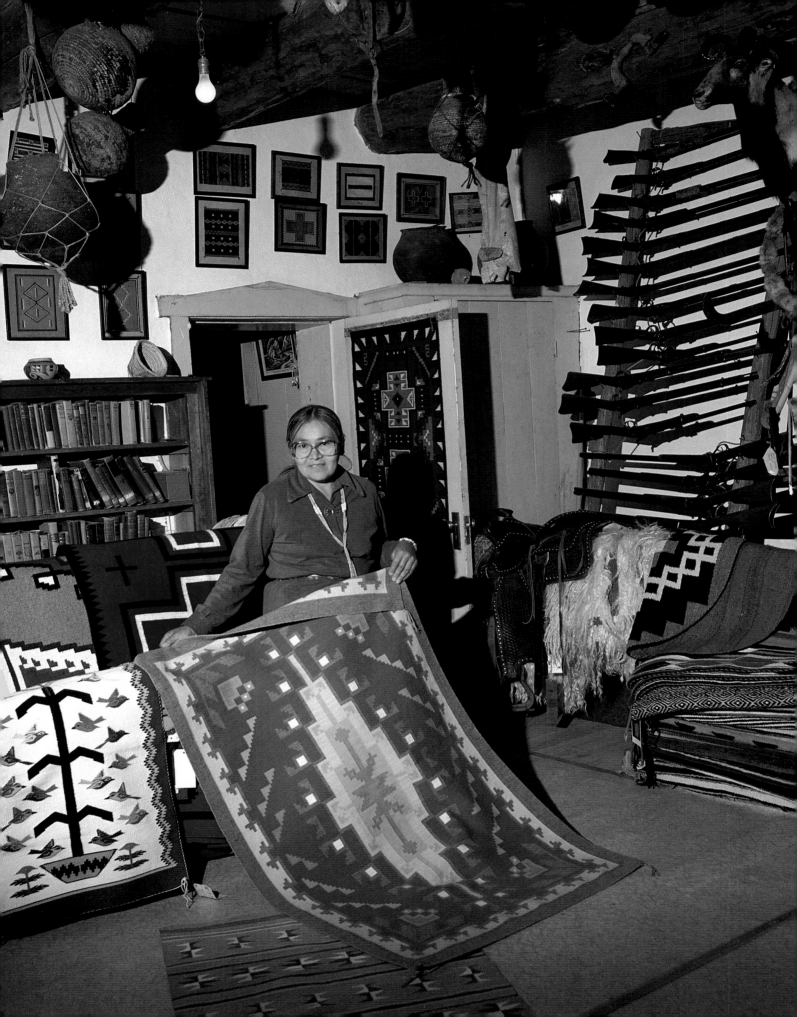

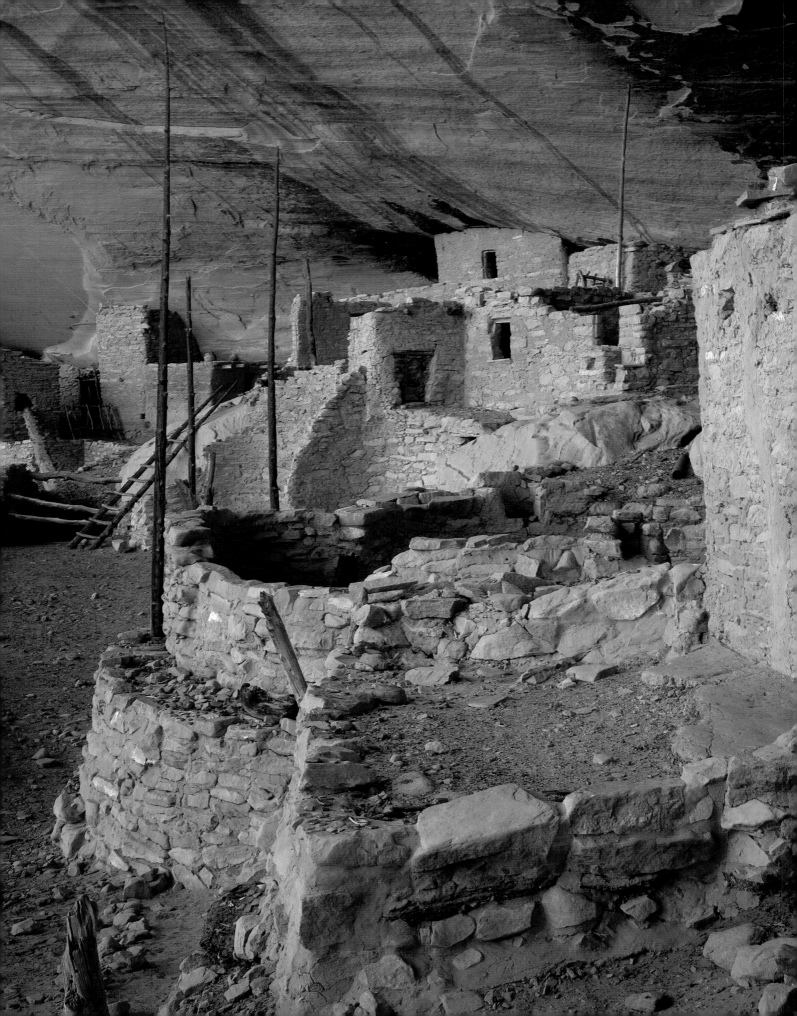

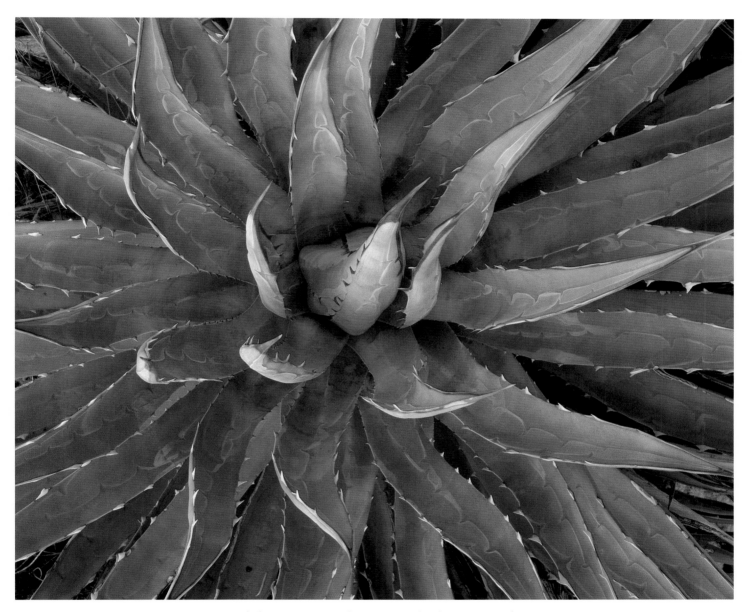

◄ *Keet Seel,* the Navajo words meaning "broken pieces of pottery,"
is the best-preserved large Anasazi ruin in Arizona. Permits, which
are available at Navajo National Monument, allow visitors to hike
eight miles to this village, occupied from about A.D. 950 to 1300.
▲ The whorled leaves of the Utah century plant create an intricate
pattern at Nankoweap Canyon in Grand Canyon National Park.

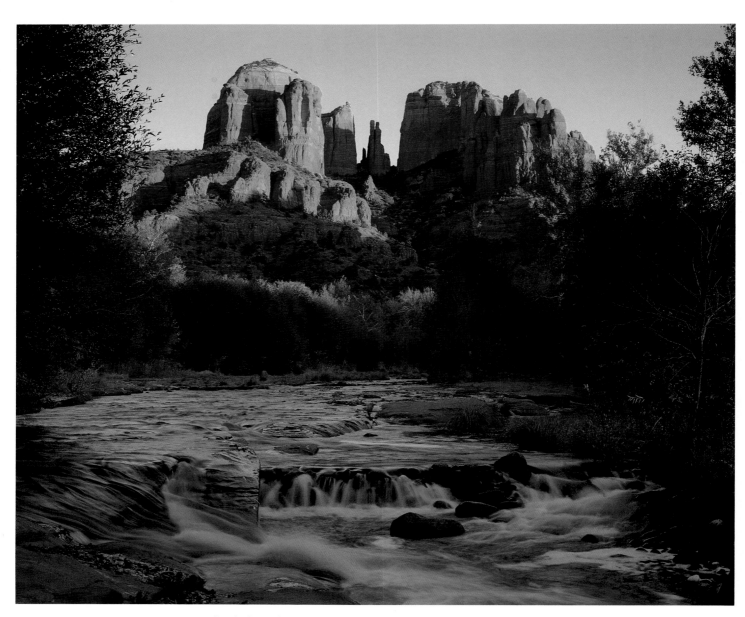

▲ Cathedral Rock catches the autumn light as water tumbles down Oak Creek at Red Rock Crossing. ▶ Sandstone cliffs tower high above Oak Creek's West Fork in the Red Rock-Secret Mountain Wilderness of Coconino National Forest. The Sedona area, on the Colorado Plateau's southern edge, has striking red rock scenery.

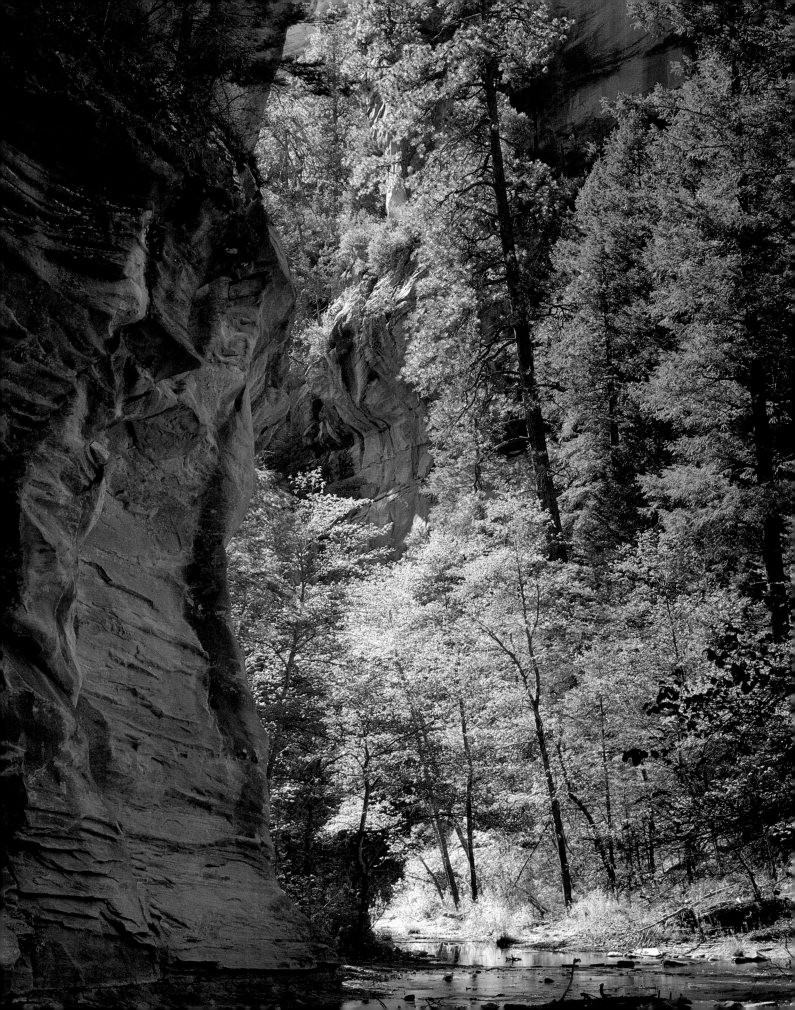

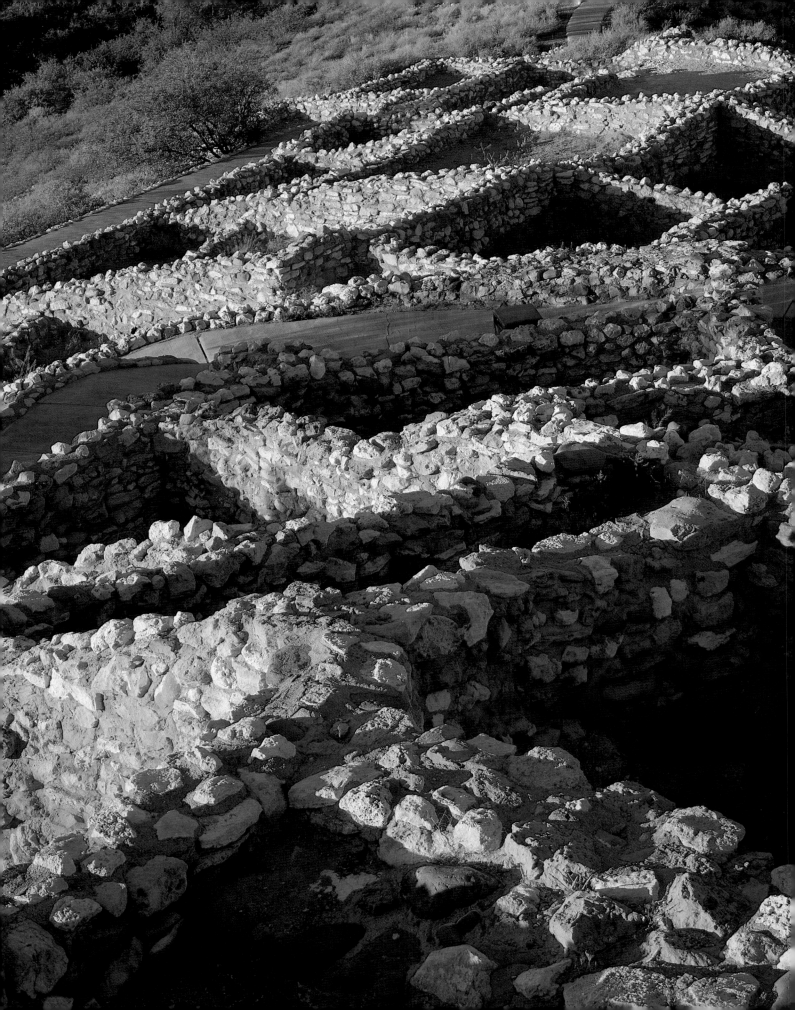

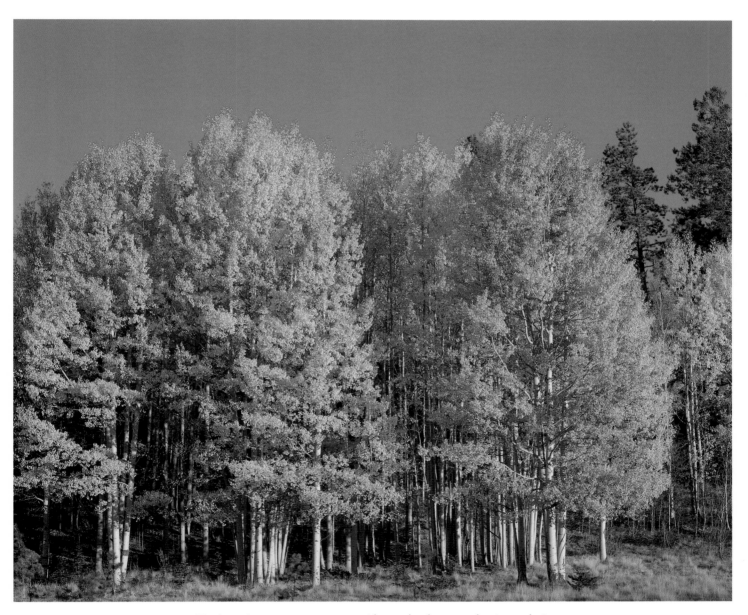

◄ Tuzigoot's stone masonry withstands the weathering of time in the lush Verde Valley. People of the Sinagua Tradition occupied this village of ninety-two rooms until about A.D. 1450. ▲ Stately aspens turn gold in autumn splendor near Hay Lake in Apache National Forest. Hay Lake is one of Arizona's few natural lakes.

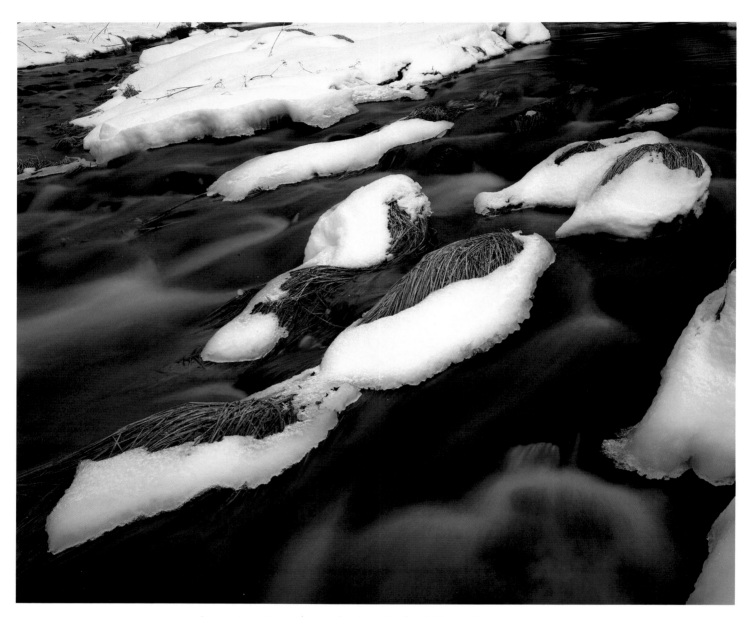

▲ Snow tops tussocks in the East Fork of Black River in Apache National Forest. ▶ Left by a winter storm, rime coats the ponderosa pines near the edge of the Mogollon Rim in the Sitgreaves National Forest. At an elevation of more than seventy-five hundred feet, the Arizona winter is at the same time both severe and beautiful.

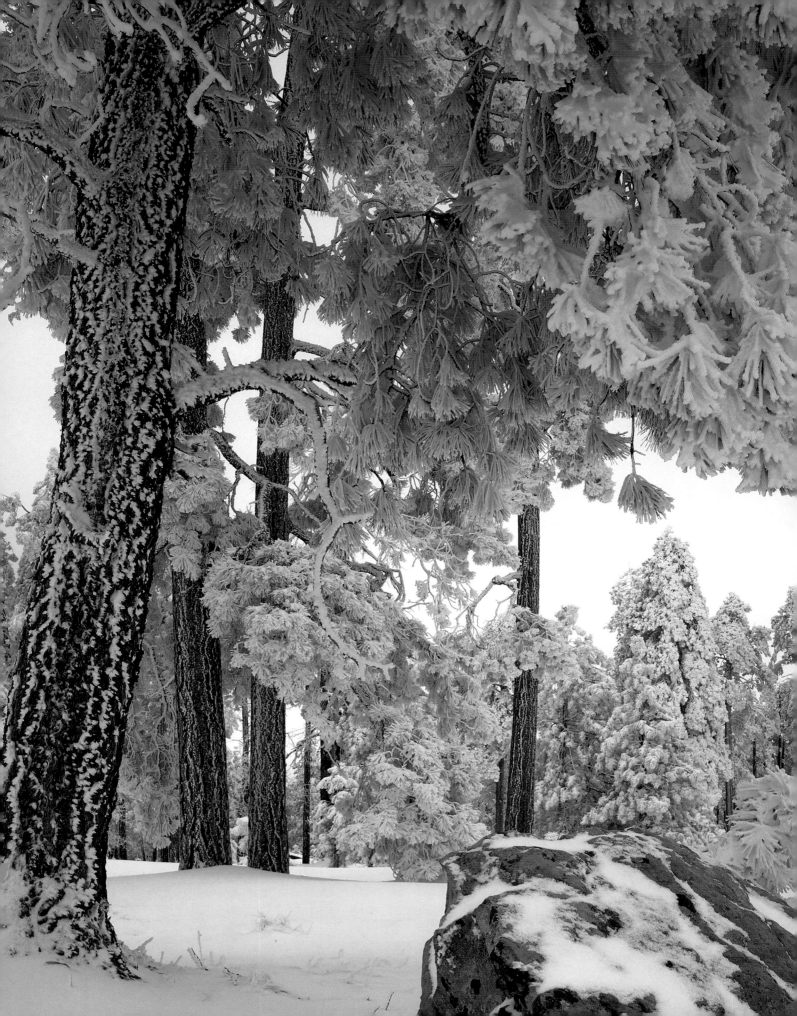

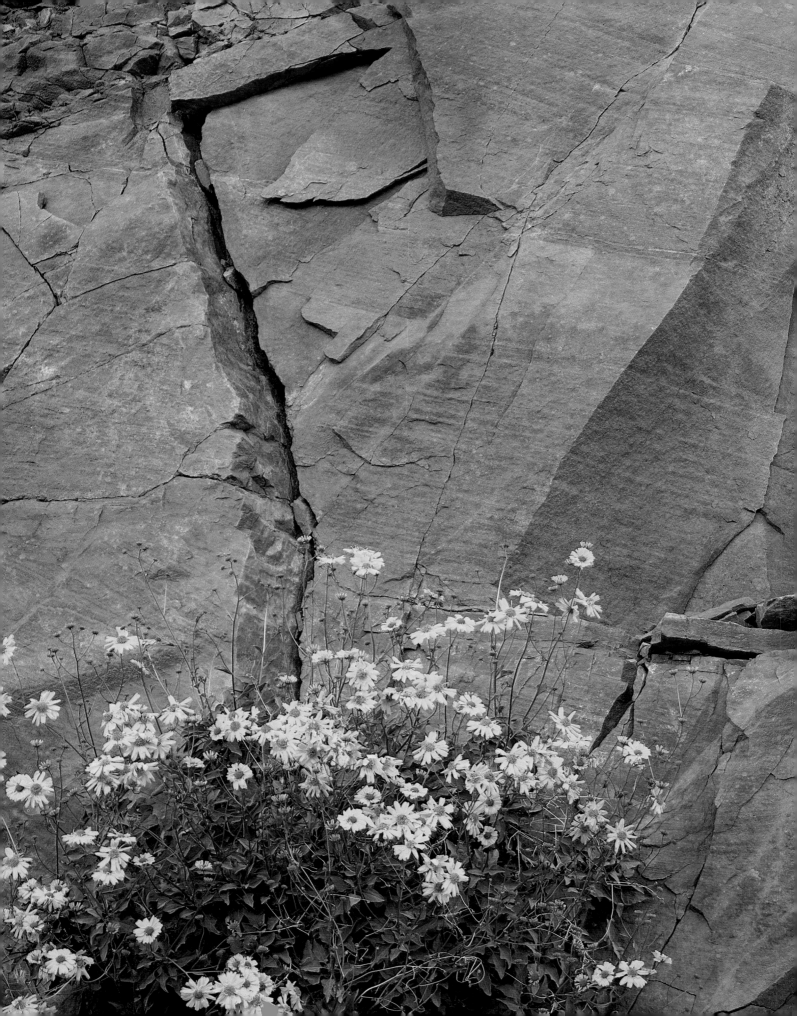

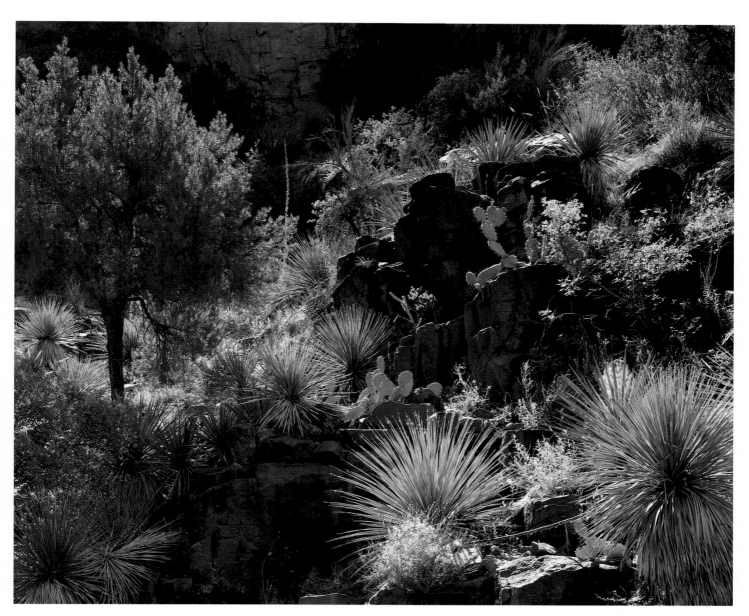

◄ Growing from a crack in a cliff overhanging the Salt River in the Tonto National Forest, brittlebush somehow finds sufficient water and nourishment. ▲ Sotol, prickly pear, and juniper grow on tiny ledges in Cibecue Canyon. ►► Cobbles, evenly spaced over thousands of years, create an interesting desert pavement near Christmas Pass in the Cabeza Prieta National Wildlife Refuge.

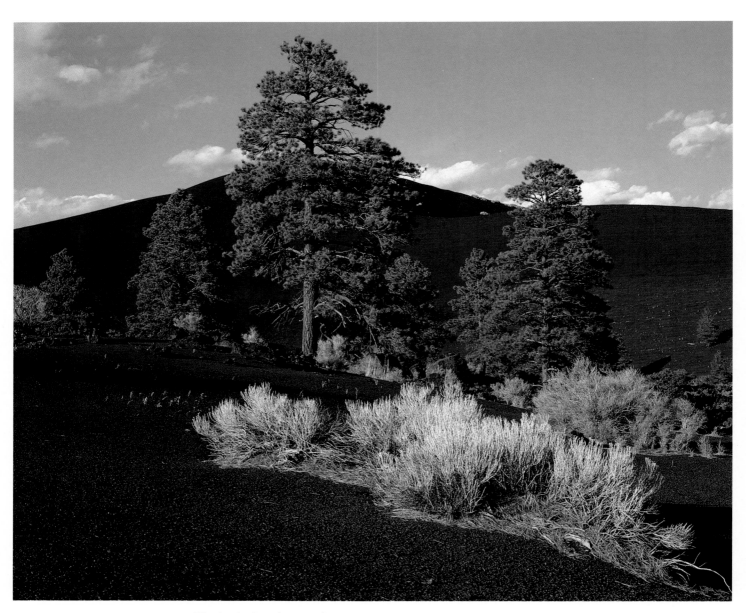

▲ Black cinders from volcanic eruptions as recent as A.D. 1064 to 1065 contrast with ponderosa pines at Sunset Crater National Monument. Much of Arizona has its roots in fiery volcanism.
▶ Seeping water in Rock Canyon, a tributary of the Salt River, supports a lush oasis. Scarlet hedge-nettle adds color to spring.

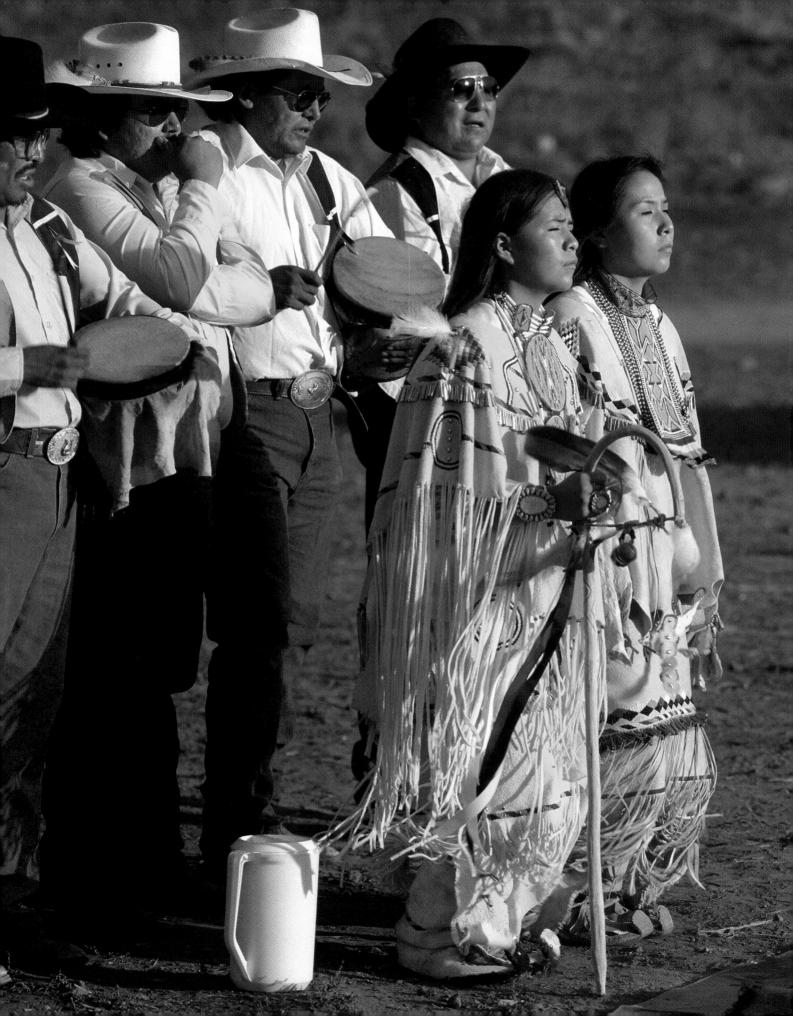

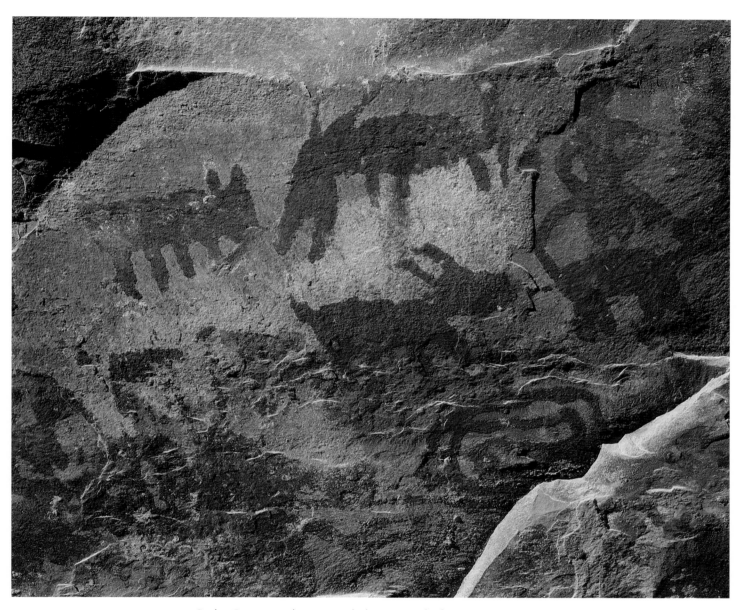

◄ Carla Goseyun dances with her sister before singers at a traditional Apache Sunrise Ceremony in Whiteriver. The four-day ceremony will bring eleven-year-old Carla into womanhood.
▲ Near Palatki Ruin in the Red Rocks area of Coconino National Forest, Southern Sinagua pictographs peer across the centuries.

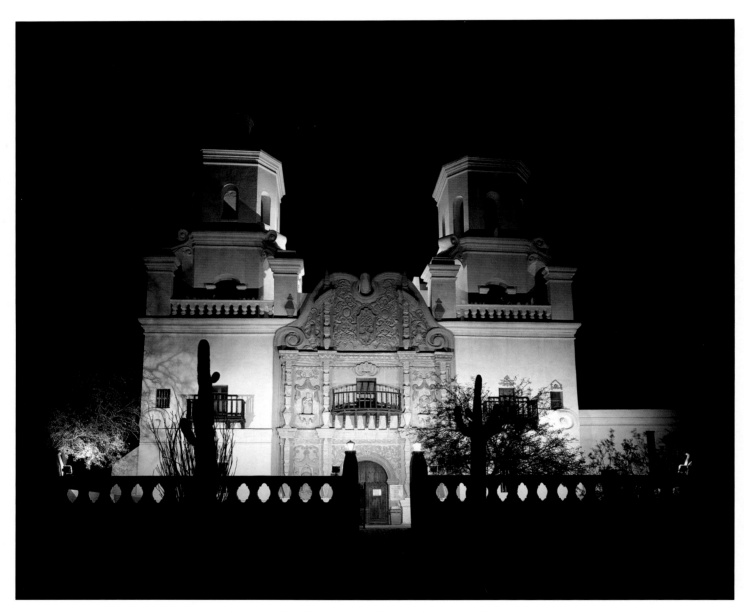

▲ Acclaimed as the finest example of mission architecture in the United States, Misión San Xavier del Bac was constructed by the Sons of St. Francis of Assisi in the late eighteenth century. ▶ The skyscrapers of downtown Tucson provide a backdrop for a statue of General Francisco Villa. Titled "In Friendship," this piece was given to the state of Arizona by the president of Mexico.

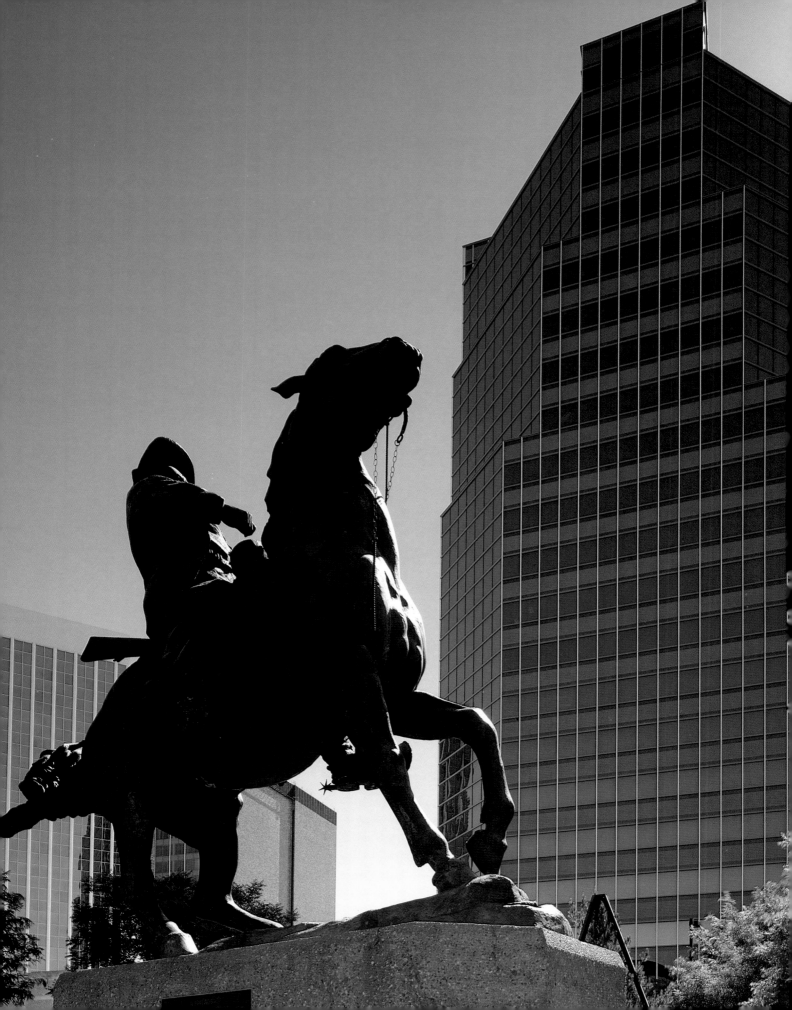

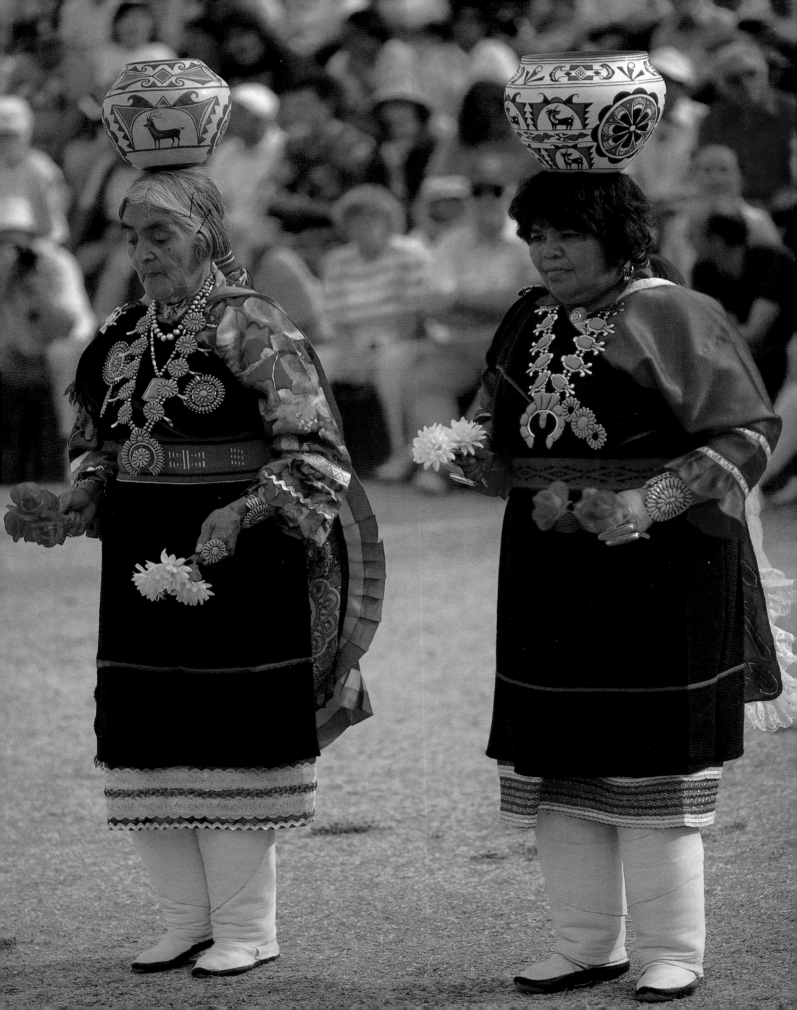

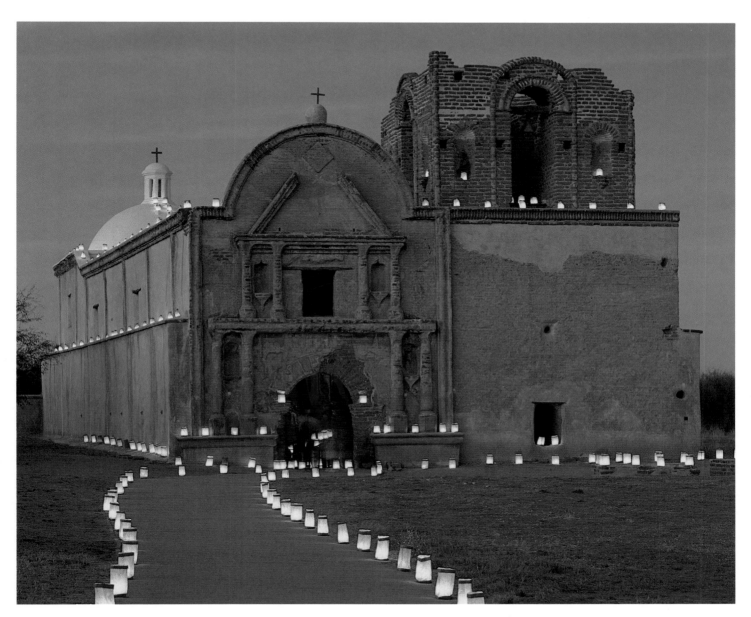

◄ Zuni Olla Maiden Dancers perform a pottery dance for visitors at the Heard Museum Guild Native American Fair in Phoenix. The Heard houses one of North America's finest collections of Native American art and artifacts. ▲ Luminarios outline the 200-year-old Misión Tumacacori on Christmas Eve. The lighting of luminarios is a Southwest tradition continued by the National Park Service.

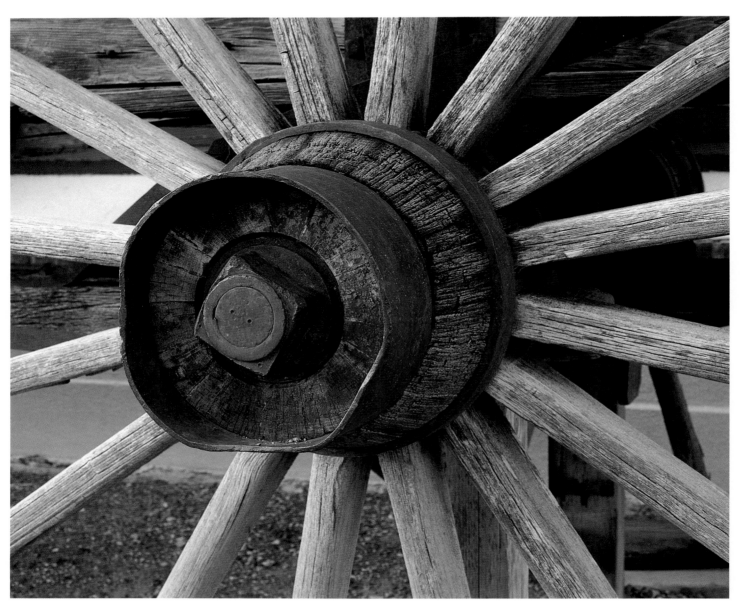

▲ An ore wagon, weathered by years, rests at Jerome State Historic Park. When Jerome hit its heyday in the early 1900s, the community was affectionately called "the billion-dollar copper camp."

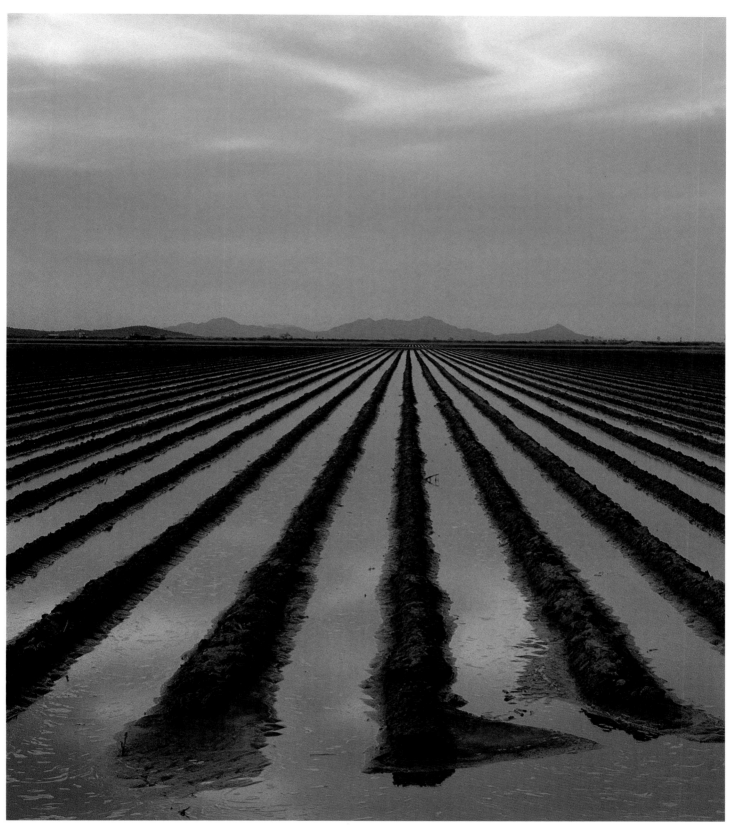

▲ Irrigated farmlands appear to stretch to the horizon near Arizona City. Cotton is the most important commercial crop in the state. Other crops include lettuce, citrus fruits, hay, barley, and potatoes.

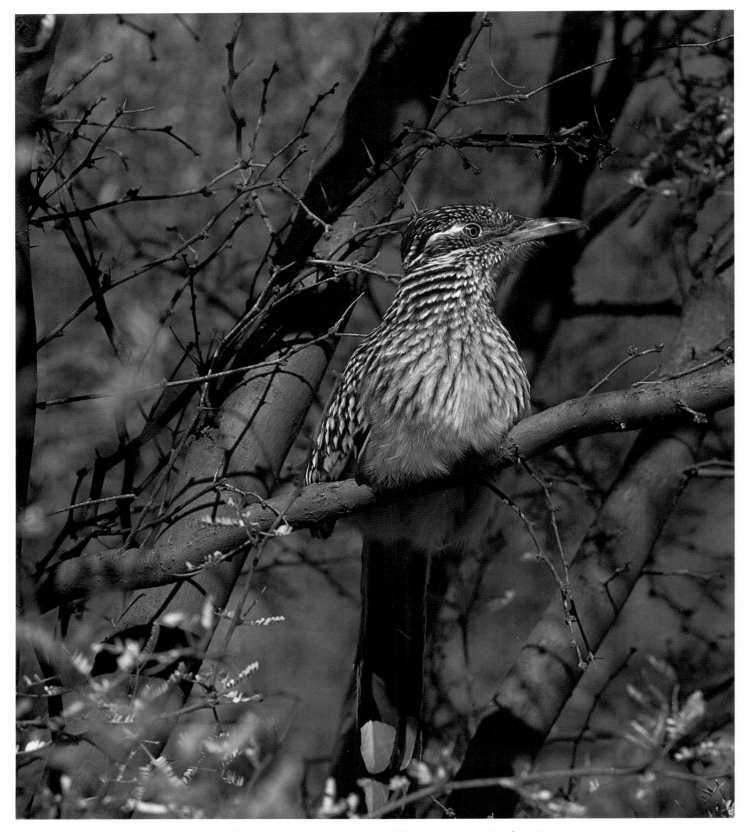

▲ A roadrunner basks in the sun while roosting in Catalina State Park. ▶ Brilliant blossoms of strawberry hedgehog cactus grace the Sonoran Desert in Organ Pipe Cactus National Monument.

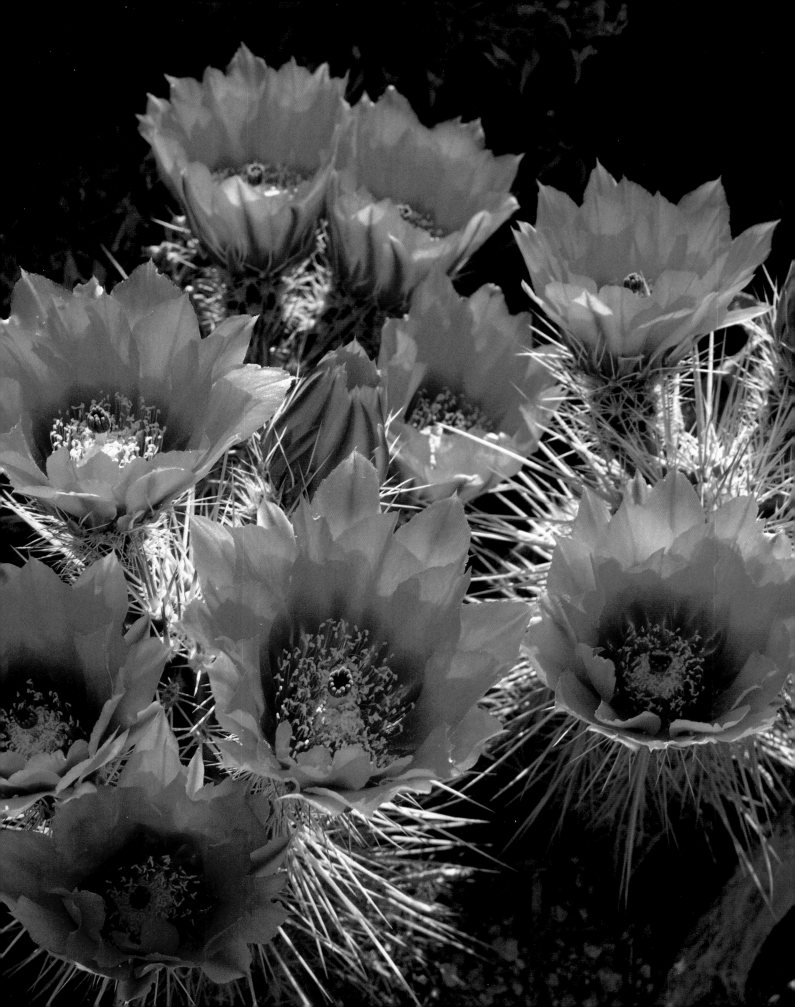

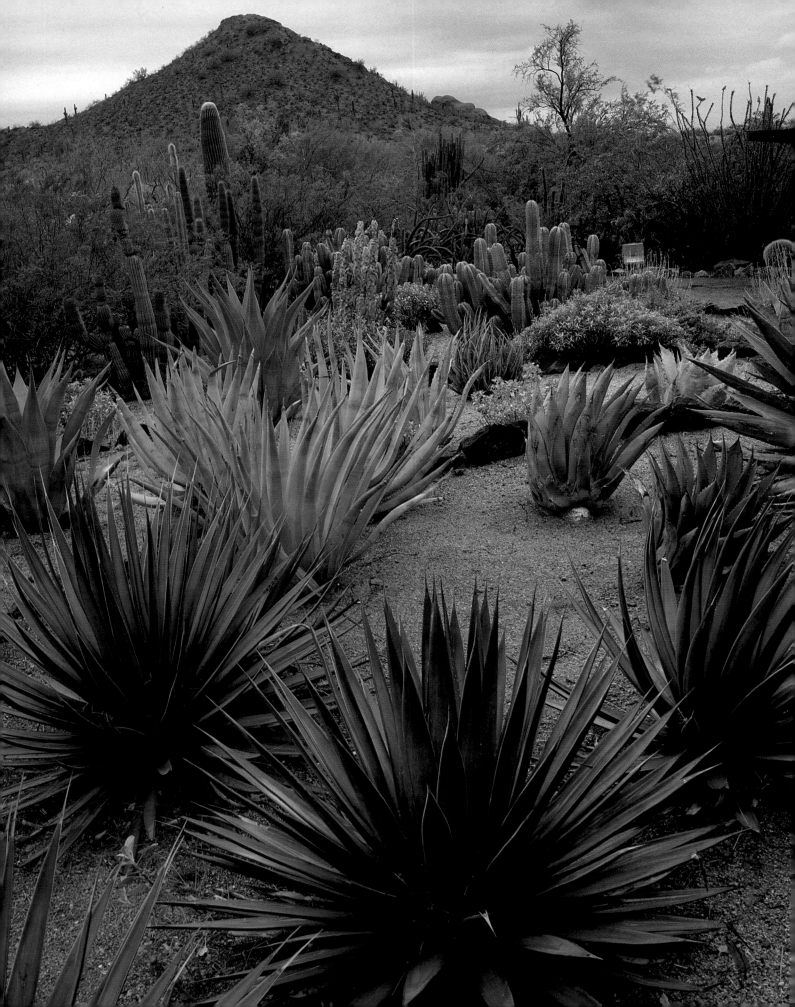

◄ Agaves thrive at the Phoenix Desert Botanical Garden. ▲ Sand verbena decorates the Redfield Canyon in the Galiuro Mountains. ►► Blooming saguaros reach for the sky in Saguaro National Park.

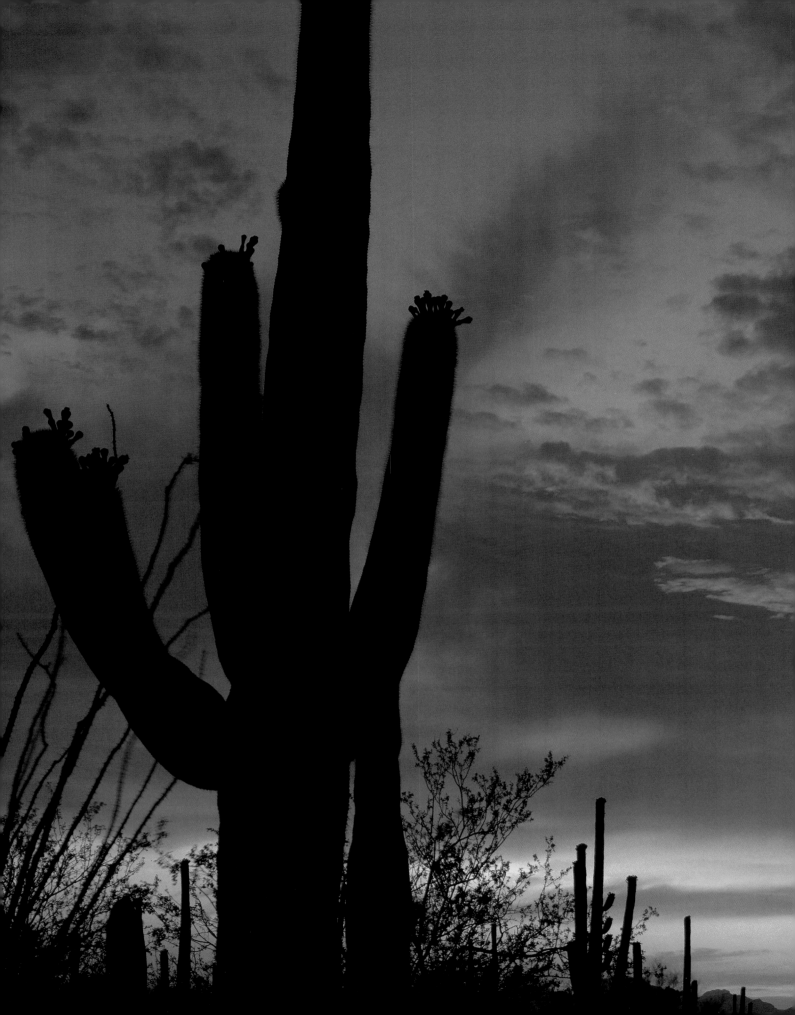

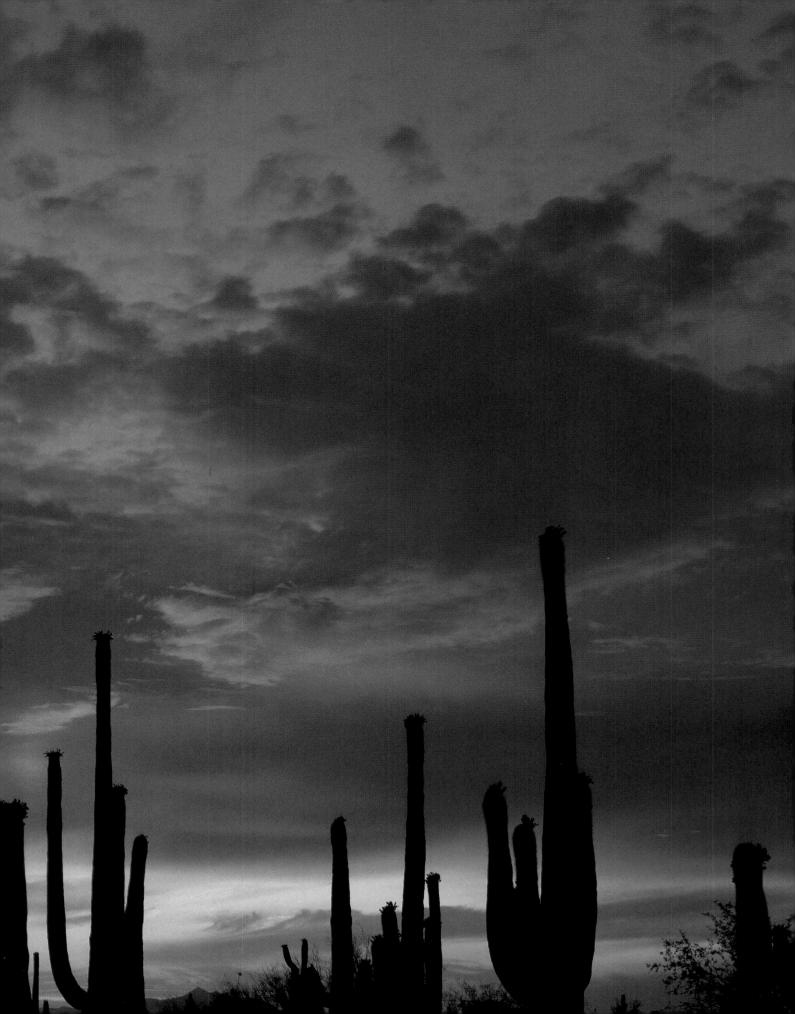

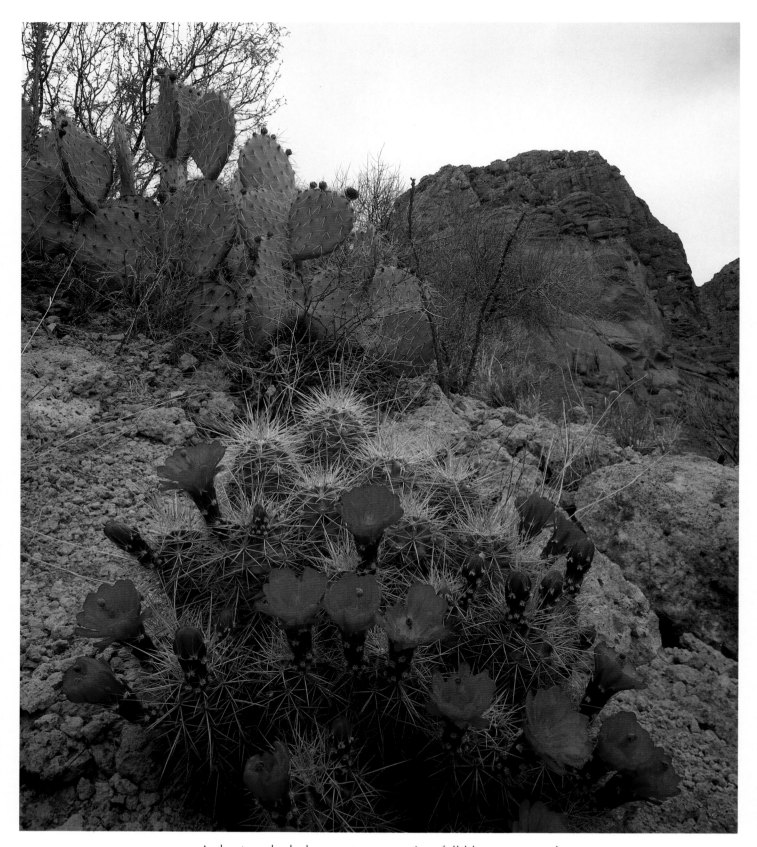

▲ A claretcup hedgehog cactus comes into full bloom on a rocky slope of Redfield Canyon. ▶ Saguaros on the Tohono O'odham Reservation may begin to bloom in April; their peak is in May.

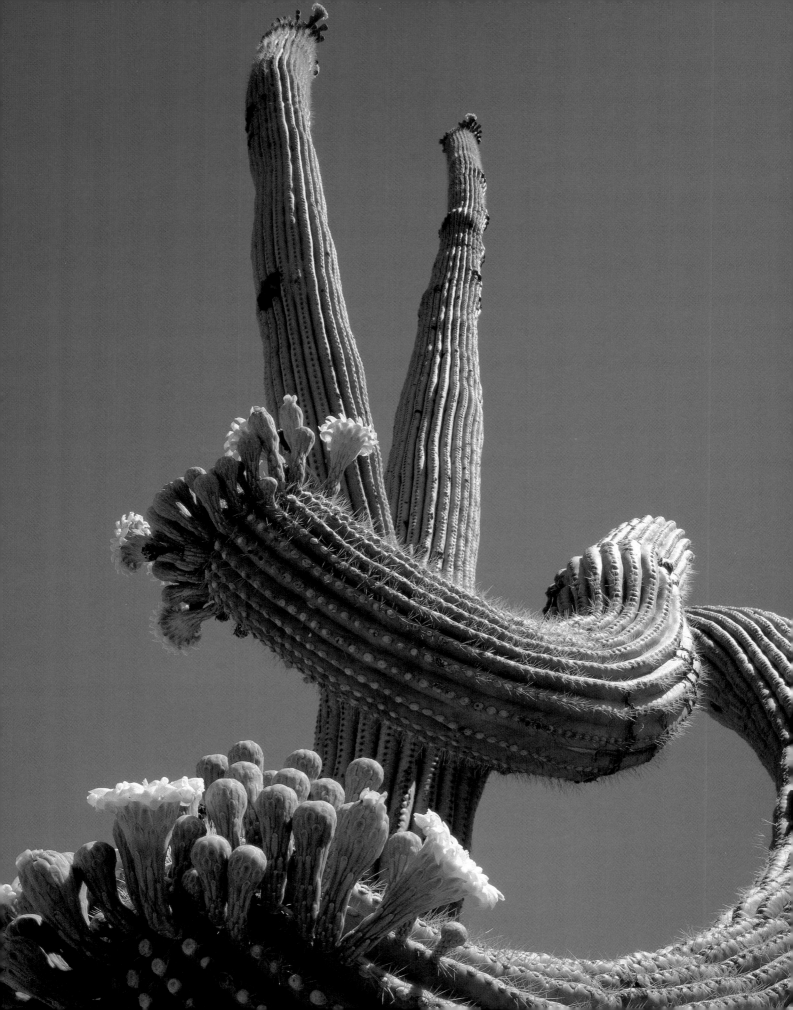

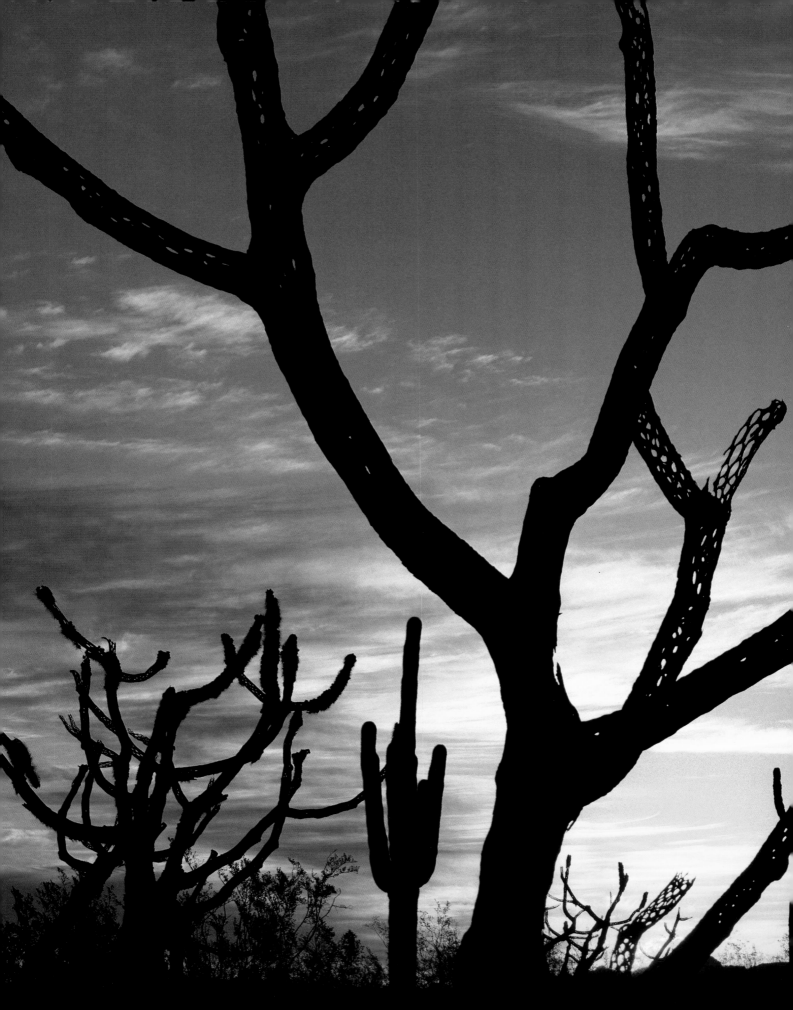

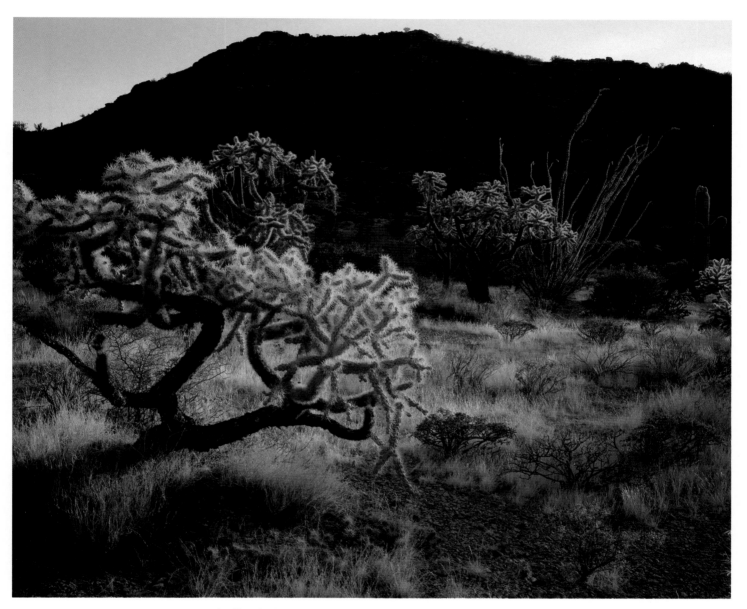

◄ A cholla skeleton stands in Cabeza Prieta National Wildlife Refuge. An annual rainfall ranging from three to nine inches supports more than 275 plant species on the refuge. ▲ Chain-fruit cholla and ocotillo grow on the *bajadas,* the low-lying gravel slopes of the Ajo Range in Organ Pipe Cactus National Monument.

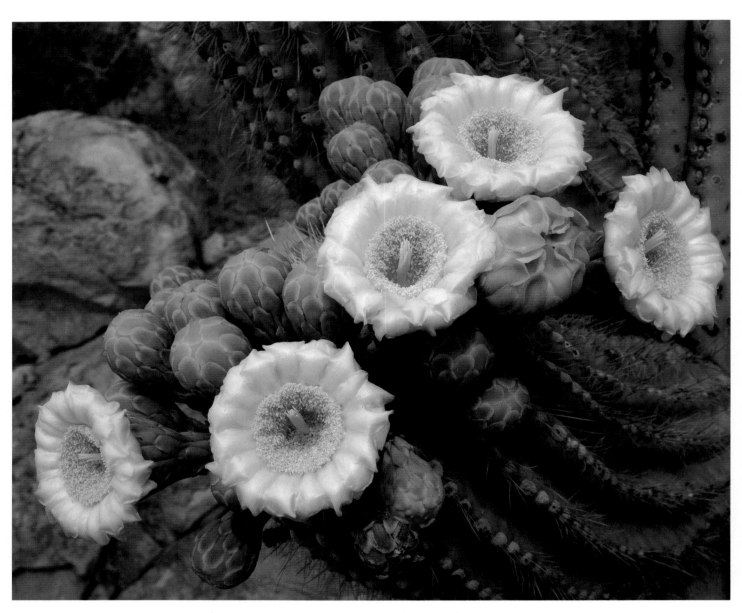

▲ In the Dripping Springs Mountains, blossoms decorate a saguaro. Arizona's state flower opens at night for pollination by nectar-feeding bats and remains open through midday for bees and doves to visit. ▶ Vegetation hugs a waterfall in Ramsey Canyon. The Nature Conservancy's Ramsey Canyon Preserve and the Coronado National Forest's Miller Wilderness protect much of this stream.

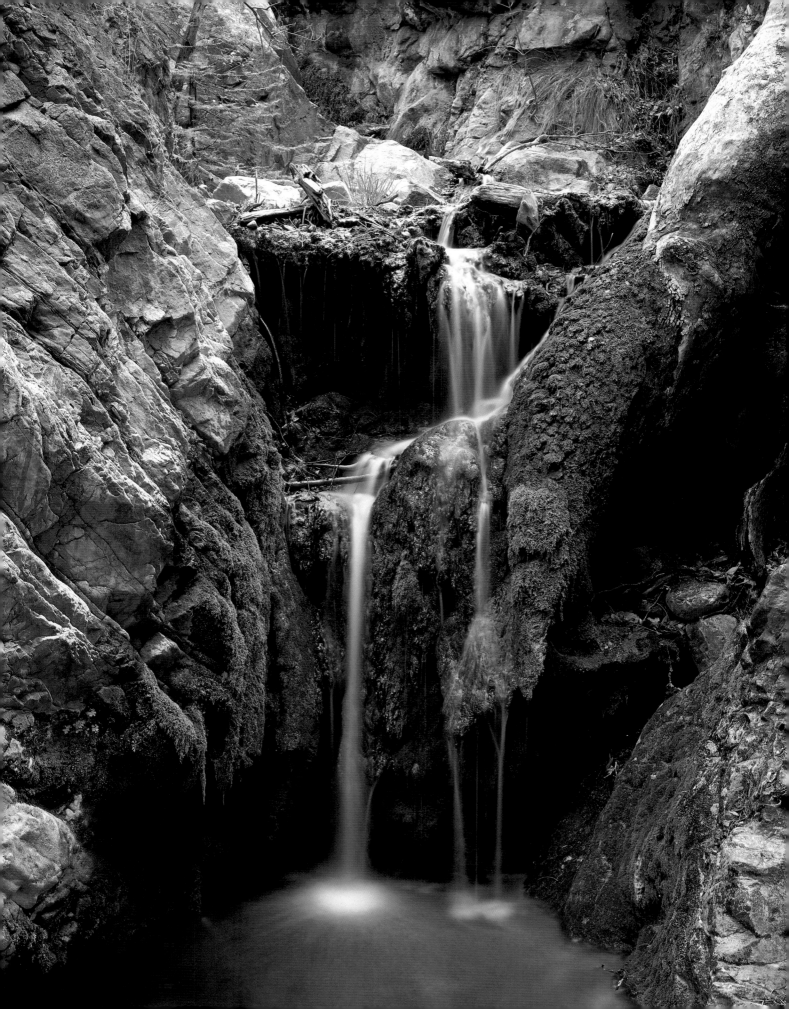

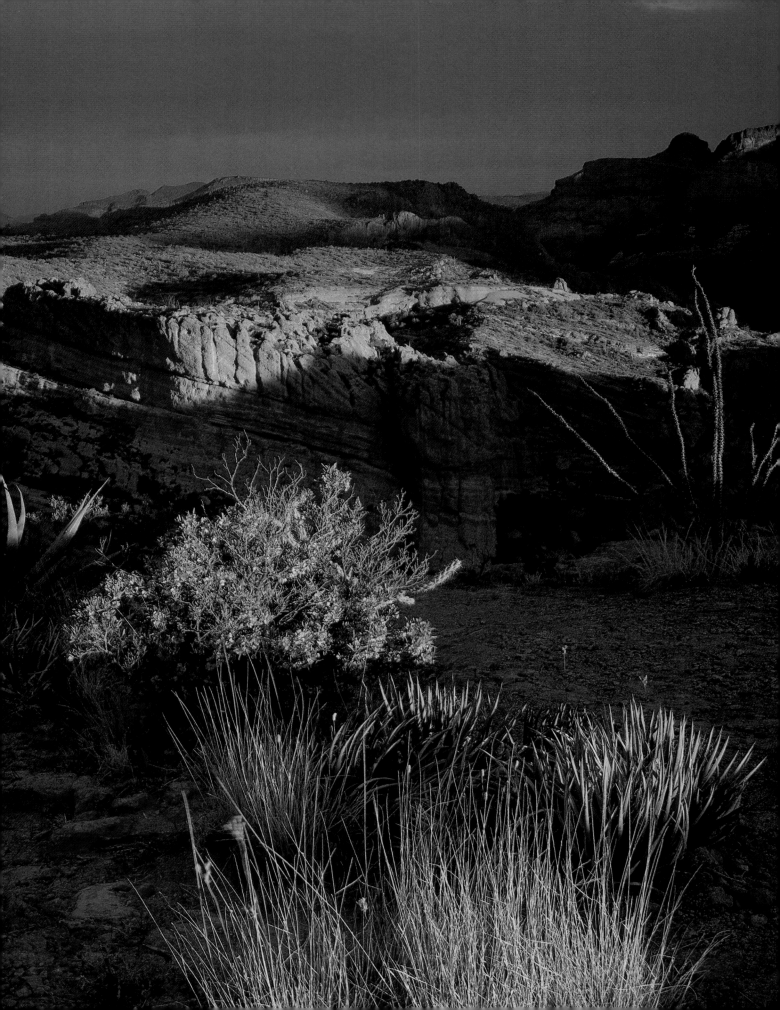

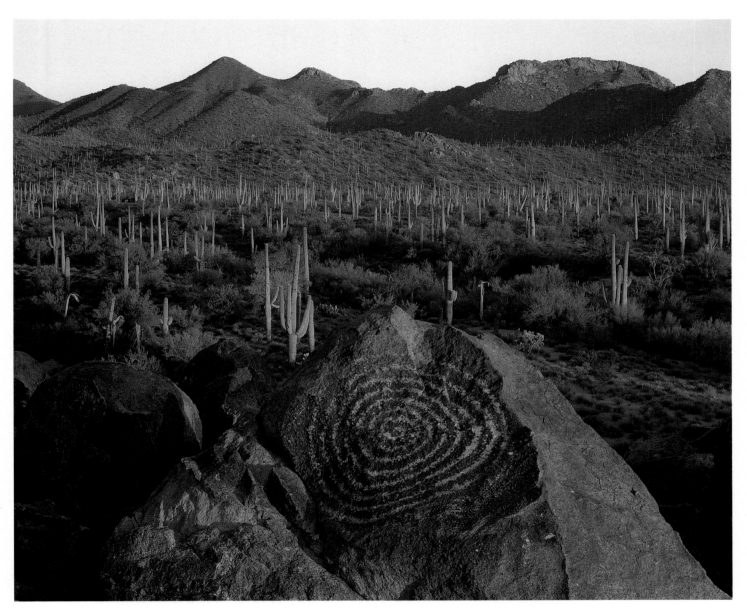

◄ On a stormy morning near the Superstition Mountains, the first rays of sunrise strike the rim of Fish Creek Canyon near its confluence with the Salt River. ▲ At the crest of Signal Hill in Saguaro National Park, a spiral petroglyph has been witness to thousands of sunsets over the surrounding acres of cactus and paloverde.

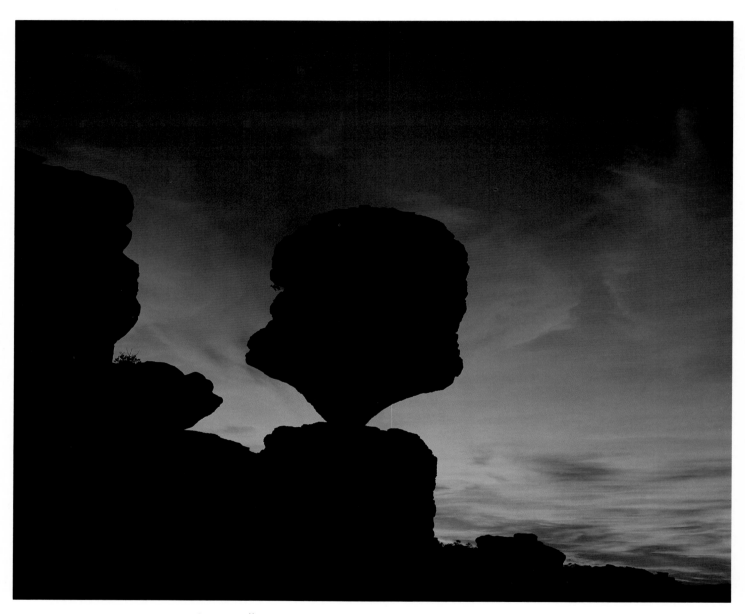

▲ Sunset silhouettes Big Balanced Rock in Chiricahua National Monument. Sights offered by the park's more than twenty miles of trails include Big Balanced Rock, Totem Pole, and Duck on a Rock.

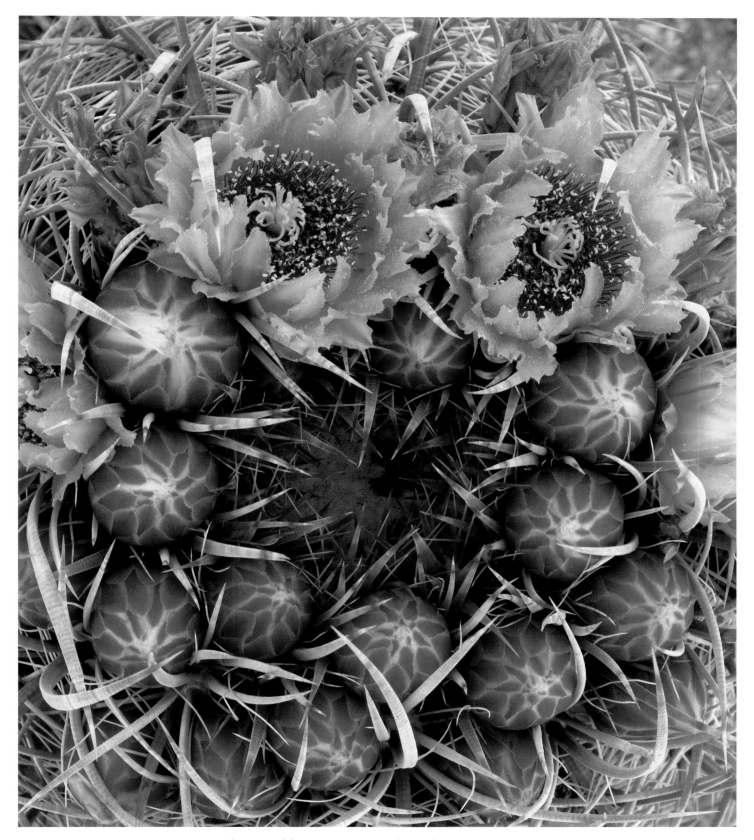

▲ Barrel cactus blossoms erupt in the Cabeza Prieta Mountains. Cabeza Prieta, along the Mexico-U.S. border, is a national wildlife refuge that preserves a fine example of Sonoran Desert habitat.

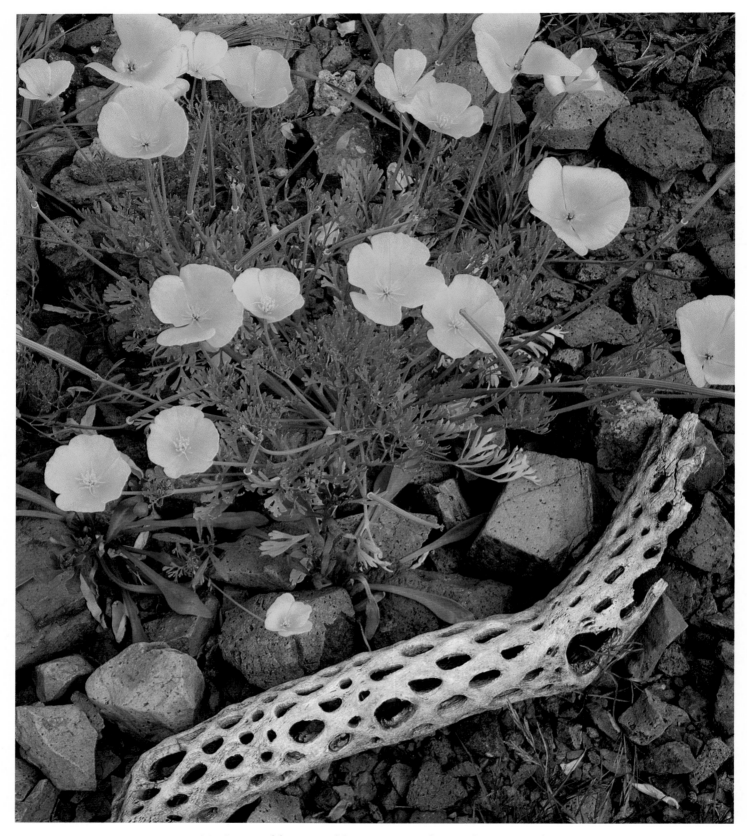

▲ Mexican goldpoppies bloom at Picacho Peak State Park. In addition to superb poppy shows, Picacho Peak is also known for a Civil War battle of April 15, 1862, which was fought in this area.